ℱoreword

quilt /kwilt/n *a bed coverlet made of two layers of cloth of which the top one is usually pieced or appliqued and having a filling of wool, cotton or down held in place by stitched designs or tufts worked through all thicknesses.*

This is the definition of a quilt. But what is an art quilt? You might say it's a quilt that's broken all the rules—a piece of fabric art that was born out of the quilter's desire to express themselves with verve, with nerve and with freedom—freedom from the rules.

In this book you'll see an overwhelming array of talent from 32 different quilt artists, each expressing themselves in their very own way. Some use traditional quilting techniques with their own original take on the subject, and others tell their story in a completely unique way.

We're sure you'll be tempted to try an art quilt of your own. Use the beautiful color photographs in this book as inspiration, review the techniques on pages 72-79 and then experiment on your own. Let your imagination go, relax, feel free to experiment and most of all have fun telling your own fabric story.

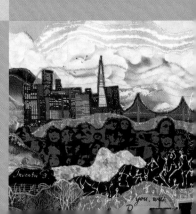

Table of Contents

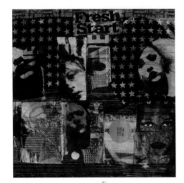

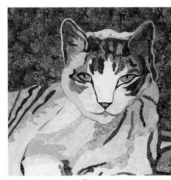

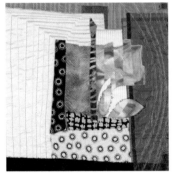

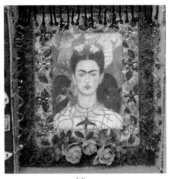

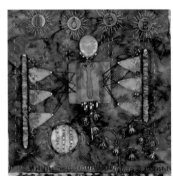

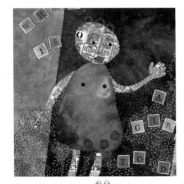

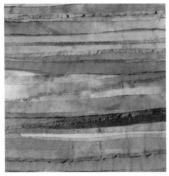

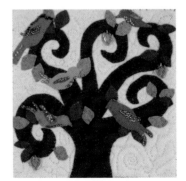

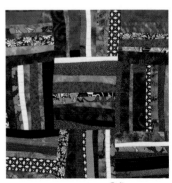

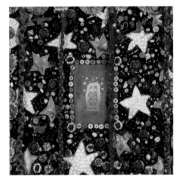
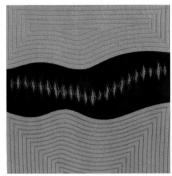
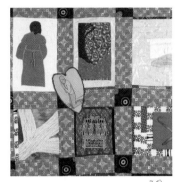
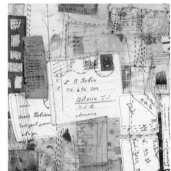
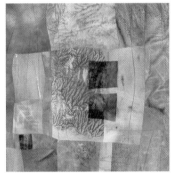
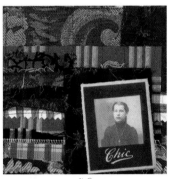
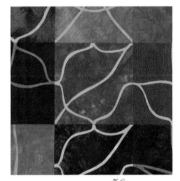
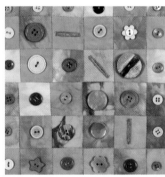
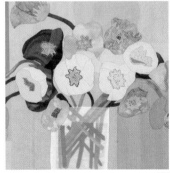

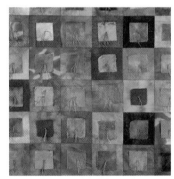
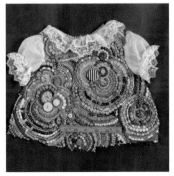
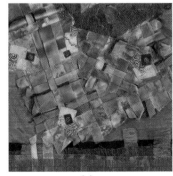
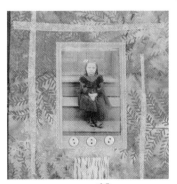
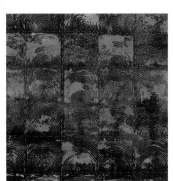

Fresh Start

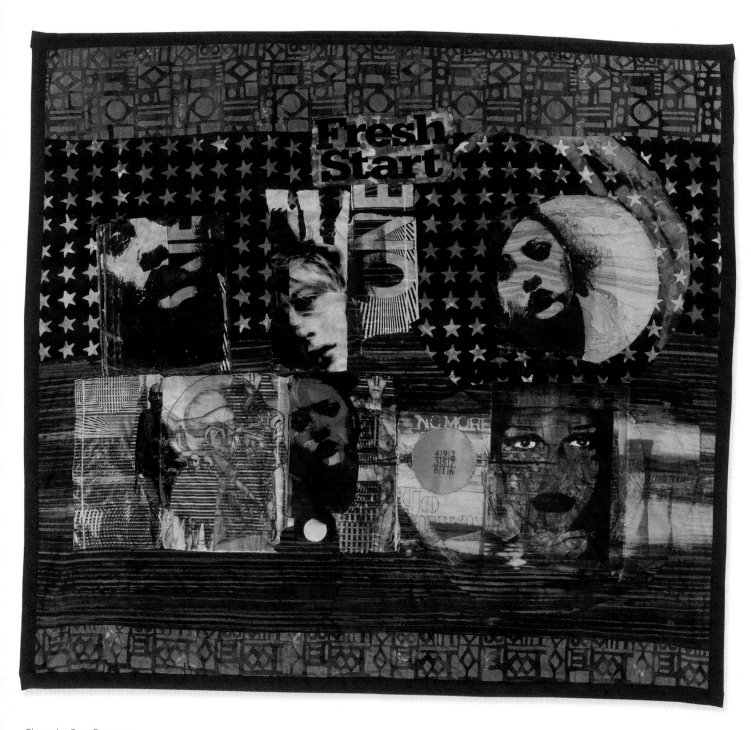

Photo by Sam Brewster

Eliza Brewster

To construct her pieces, Eliza uses cotton fabrics which are hand-appliquéd, hand-quilted and stenciled. To create the images for the quilt, she uses photo transfers. She also uses a combination of colored markers and color discharge dye techniques to add the vibrant shades and hues to her work.

Her work is improvised. The piece evolves as she develops it, it's never pre-planned. Starting with a glimmer of a concept, Eliza says the finished quilt ends up with very little of her original idea. And this is what's most exciting to her—that she never knows exactly how her statement will appear until the quilt is finished.

...she never knows exactly how her statement will appear until the quilt is finished.

Eliza Brewster was born in New York City and now lives in Honesdale, Pennsylvania with her husband, Sam.

She attended the Rhode Island School of Design and the Art Students League where she studied print making and etching.

Her quilts have been exhibited at the American Quilter's Society show in Paducah, Kentucky; the Matrix Art International show in Sacramento, California; and Quilt National in Athens, Ohio, among others. She has also had several solo exhibits at various galleries.

5

Robin Cowley

As a child, Robin started sewing, or as she says "building something—putting two pieces of fabric together and creating a construction."

After working in the landscape and construction industry and tiring of numbers and print-outs, she felt a strong need to go back to art. She studied art history, color theory, drawing, sculpting, print making and painting. She combined her love of fabrics with her flair for painting and started turning out quilts. Her pieces combine the best of both worlds, using color and space in an abstract manner to engage viewers with their humor and lightness. You can see some of that humor in these pieces, each one incorporating Robin's love of color, design and structure.

"There's a tactile sensation centered around the 'hand' of cloth that gives me great joy", says Robin. The feel is as important as the color and pattern. She refers to her pieces as textile constructions.

Robin draws her inspiration from the world around her—architecture, views of the earth and skies and the many colors and textures of nature. Her works are generally machine-pieced and quilted, with hand-appliqué, inks, hand-painted and hand-dyed elements.

Robin has had several solo exhibitions, been in a number of group exhibitions, had her pieces included in several publications as well as appearing on national television. She has had several of her works commissioned.

Currently Robin lives in Oakland, California.

Inside/Out is a series that represents a personal growth for Robin. It evolved from ideas about good fortune, magic powers and gold charms for luck, as well as bringing her own personal thoughts and memories from deep inside to the surface. These pieces show the inner workings. Layers that would normally be hidden are deliberately left hanging out for the viewer to ponder. The rough and ragged edges offer a glimpse of the process.

She uses color and space in an abstract manner to engage viewers with their humor and lightness.

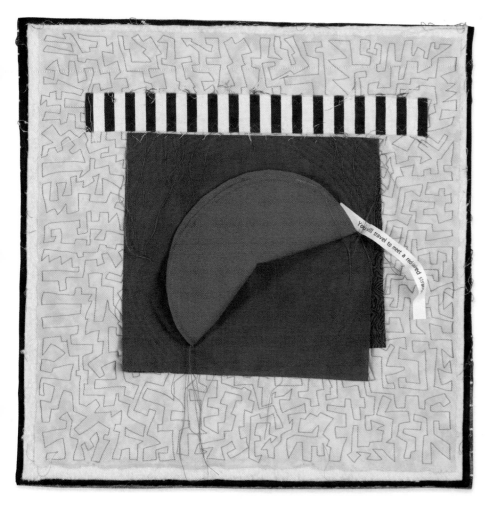

18½" x 18½"

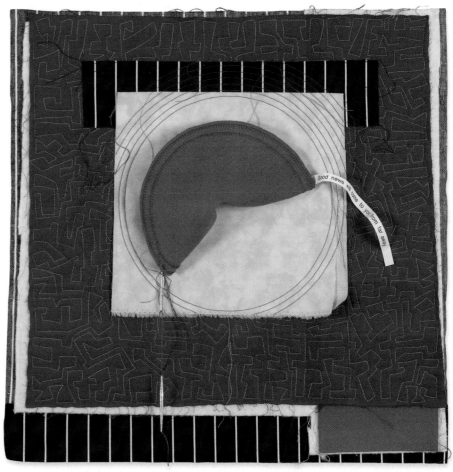

18½" x 18½"

Grace Errea

Sewing has always been Grace's passion. She's always at the sewing machine either making clothes for herself, her two daughters or projects for the home. With this strong background in sewing, Grace turned to quilting in 1999. She started quilting in a traditional style and quickly developed her own style of naturescape quilts. Her original designed quilts are personal reflections of photographs which are then interpreted by using the texture and color of cloth as tools. Grace has had several quilts accepted in juried shows such as the International Quilt Association in Houston and Chicago, the American Quilter's Society in Paducah and Nashville, the Pacific International Quilt Festival in California, the Road to California Show, and the National Quilt Association in Columbus, Ohio.

This particular piece was machine-appliqued using both raw edge and turned edge techniques. Grace usually prefers the turned edge, but when there are places where curves are too minute and intricate, this technique doesn't work, so the raw edge is used. In addition there are also areas where raw edge works better, such as the edge of a bird's feather, the bark of trees or to denote an animal's furry coat.

The pieces of fabric were applied and then basted to a stabilizer layer with nylon thread. When the whole top was completed, it was sandwiched with batting and backing and then quilted to enhance areas that she wanted to highlight. In this piece, the design of the quilting was taken from the animal himself by following the layers of fur.

The inspiration for Grace's piece is probably obvious. As she says, "when you have a pussycat with such soulful blue eyes, how can you resist putting them into a quilt? Meet my best friend of 16 years...Jessie."

Her original designed quilts are personal reflections of photographs which are then interpreted by using the texture and color of cloth as tools.

Jessie

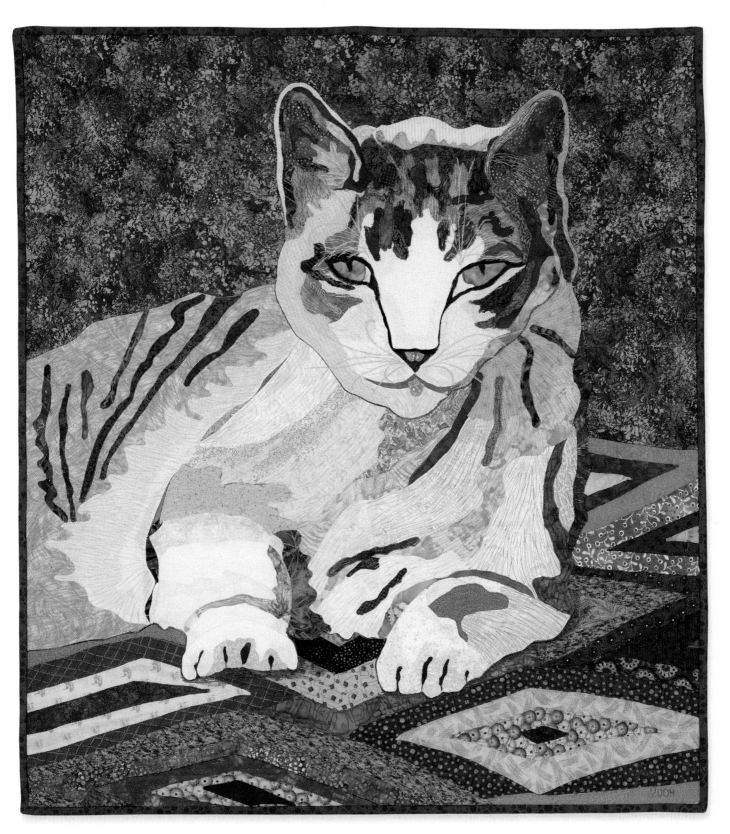

32" x 36"

Winds Blowing

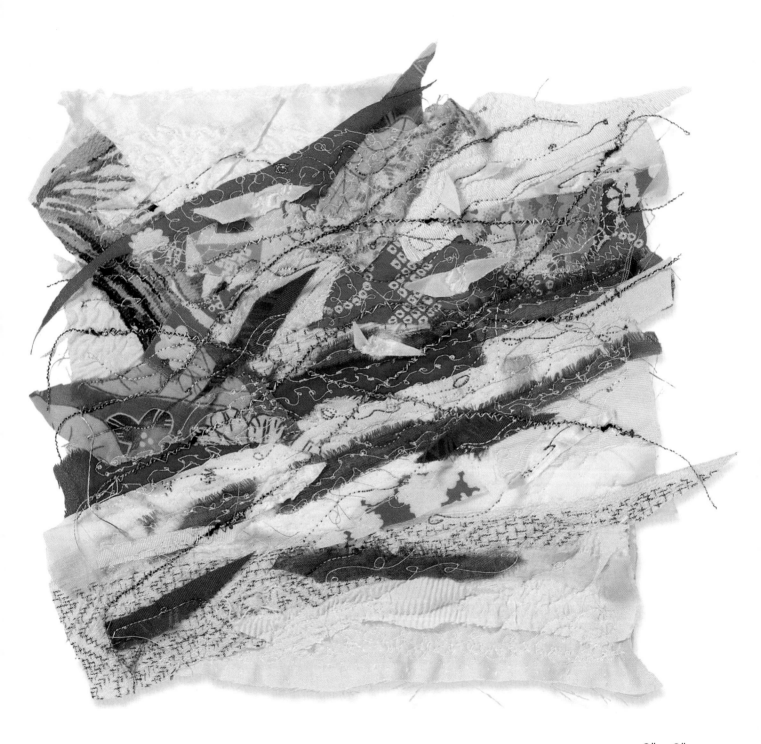

8" x 8"

Chiaki Dosho

To make this piece, Chiaki used cloth of an antique Japanese kimono. She combined this fabric with others to form interesting shapes. After all of the shapes were put together, the quilting was freely done using a combination of threads. Some of the small silk pieces seem to fly across this piece in a three-dimensional way, symbolizing, as Chiaki says, "the winds blowing in the sky."

This talented quilt artist was born in Japan and lives in Kanagawa, Japan with her husband and daughter.

After learning to quilt, Chiaki decided to return to school to further her education and attended Musashino Art University. Along the way she married and had children, so her education stopped and started until she finally finished. She has been quilting ever since—for the past 18 years.

Her quilting has evolved until it is now a very free form type of art. She has exhibited her art quilts in various competitions in Japan, the United States and France. She has been involved in two solo shows in an art gallery in Japan. She was also selected to exhibit at the 2005 Quilt National show in Athens, Ohio.

Besides quilting, Chiaki is also a photographer and is planning a one-woman mixed-media show in 2006 as her third solo show.

…silk pieces seem to fly across this piece in a three-dimensional way, symbolizing, as Chiaki says "the winds blowing in the sky."

Elizabeth Fram

Elizabeth W. Fram has been making art and sewing most of her life, but didn't combine the two disciplines into one until after the birth of her children. Spurred by the desire to mesh the welcome demands of a growing family with the drive to create, she has found textile collage to be a medium that mutually benefits and easily conforms to this challenging duality.

In addition to two solo shows in Pennsylvania, her textile collages have been shown in group exhibitions nationally, including the Thirteen Moons Gallery in Santa Fe, New Mexico; the APEX Gallery in Washington DC; the West Branch Gallery and Sculpture Park in Stowe, Vermont; and the Gallery of Fine Art in Newtown, Pennsylvania. Ms. Fram's work is represented in numerous private collections throughout the United States.

A feature article on Elizabeth's works appeared in the Philadelphia Inquirer in October of 2004, highlighting her work's emphasis on the intricacies and nuances of daily life. She employs a multitude of processes that underscore the unique attributes of fiber as an artistic medium. Many of her methods are self-taught.

Ms. Fram was born and raised in Portland, Maine. She graduated with a degree in art from Middlebury College in Middlebury, Vermont. Currently, she resides in Washington Crossing, Pennsylvania with her husband and two teenage children.

This piece began with an oil pastel drawing. Once the drawing was complete, Elizabeth cut it into strips. By rearranging and reassembling the strips side-by-side and then gluing them to a base sheet of paper, a "new" drawing was created. The image was then taken to a copy shop where they copied it onto photo transfer paper and then transferred it onto Pimatex Cotton PFD, creating a unique fabric from which to base the collage.

The rest of the process was largely intuitive. Elizabeth never follows a predetermined pattern, but rather uses an idea from her sketchbook as a departure point. As she continues, the piece evolves around that core idea.

She likes to utilize fabrics of varying textures, weights and sheens. They are layered and "auditioned" until she finds a grouping that works together as a whole. Color is her main motivating factor. Shapes are cut and assembled with much experimentation and revision. This piece was appliquéd in its entirety; there is no traditional piecing.

The edges are left raw, and vertical straight stitches were used to appliqué the elements together by hand. Some pieces were appliquéd by machine, sewing just inside the edge of the shapes. Hand embroidery was added to emphasize or fill out a shape, often introducing a new color and adding texture. The quilting serves as an integral component that leads the eye around the piece. Through the inclusion of all these processes: the oil pastel drawings, hand appliqué, hand embroidery, as well as the immediacy suggested by the raw edges, Elizabeth aims to emphasize her presence and hand within each piece.

The main inspiration behind "Waiting to Merge" is the idea that attaining one's goals is a function of patience as well as hard work and perseverance.

Waiting to Merge

21" x 23"

The Frida Shrine

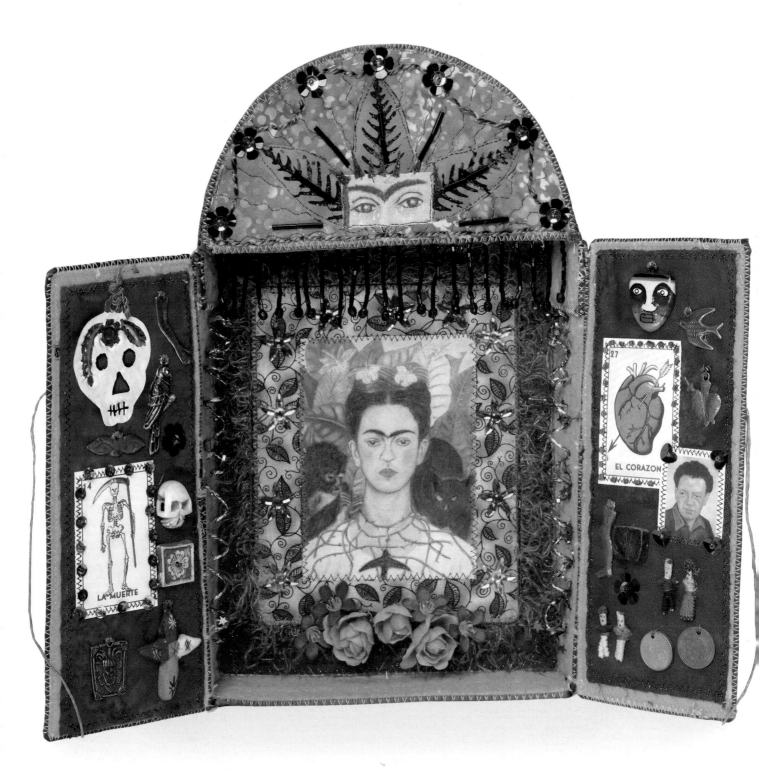

7" x 11" x 1½"

Janet Ghio

Frida Kahlo is a favorite subject for many of Janet's fabric pieces. The imagery and symbols used in Kahlo's work make her a perfect subject for iconography. The Frida shrine that Janet has created is a good example of her work. It's created using a heavyweight stabilizer for the base, with cotton fabric for the outside and felt for the inside. On this shrine, she has incorporated photo transfers for the Frida images and the portrait of Diego, appliquéd flowers, charms, milagros, loteria cards, a tin skull, silk flowers, sequins and beads.

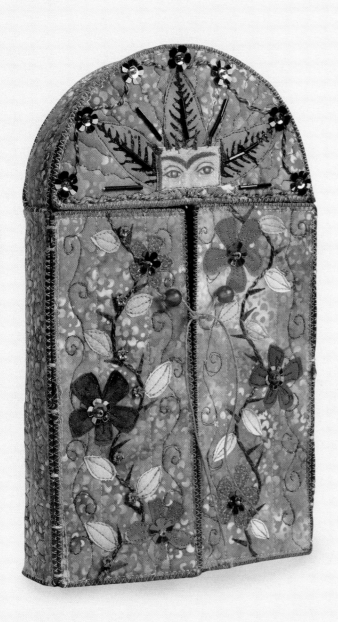

Janet comes from a long line of artists. Her great grandmother did beautiful embroidery. Her grandfather, Coy Seward was one of the Kansas Prairie Printmakers. Her mother was a painter, weaver and basket maker. As Janet grew up, she had the opportunity to experiment with different media including miniatures, watercolor, jewelry, collaged boxes and cloth dolls. She loves including a variety of media in her work but always returns to fabric and beads. Her inspiration comes from the textiles, images and symbols of other cultures, as well as her imagination.

When she was a career counselor, she encouraged people to follow their dreams. In 1996 she took her own advice, quit her full time job and now follows her own artistic dreams.

Janet's quilts have been exhibited in numerous shows and galleries nationwide. She has been published in Quilting Arts Magazine , Somerset Studio Magazine and other publications. Her quilts are in many private collections.

Betty Hirsh

*B*etty learned to sew in a junior high school home economics class. She prided herself as being the only one in her family that could sew. She's always loved working with fabric and color and wanted to be able to do more with her sewing machine. So about 15 years ago, she had a friend teach her the basics of quilt making. She's been collecting fabric and embellishments and making various quilt pieces ever since. She likes to experiment with different fabrics, fibers and media and incorporates them into her quilt pieces. Everything she makes she gives away as gifts. In addition to quilting, Betty also dabbles in various crafts.

She makes her home in Commerce City, Colorado, with her husband, Ben. They have two sons, John, who is a college student, and Ryan, 12. Betty has been a paralegal for the past 18 years.

Betty made her "Fish Bowl" design by layering muslin, cotton batting and a canvas/denim type fabric. She used spray adhesive to hold the layers together, then used free motion stitching to quilt the piece. In addition to the spray adhesive, she also used Wonder-Under for fusing. She embellished the design using blue and multi-color embroidery floss.

The canvas was stamped with a large carp design by Stamp Zia using a black ink stamp pad. She painted the fish using Pearl Ex watercolor paints from Jacquard. Various areas were accentuated using a black marker. To add further embellishment, Betty dyed some cheese cloth by soaking it in acrylic paint (Folk Art Metallic Blue Topaz and Deco Art Ice Blue Dazzling Metallics). Other embellishments include various fibers, peacock feathers, assorted beads, shells and found objects.

She likes to experiment with different fabrics, fibers and media and incorporates them into her quilt pieces.

Fish Bowl

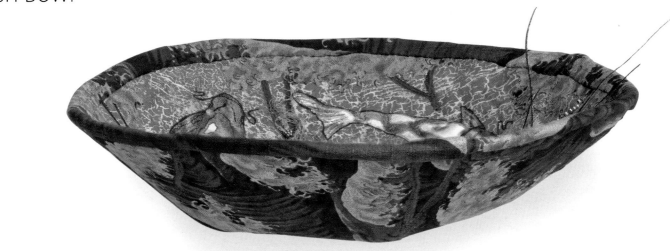

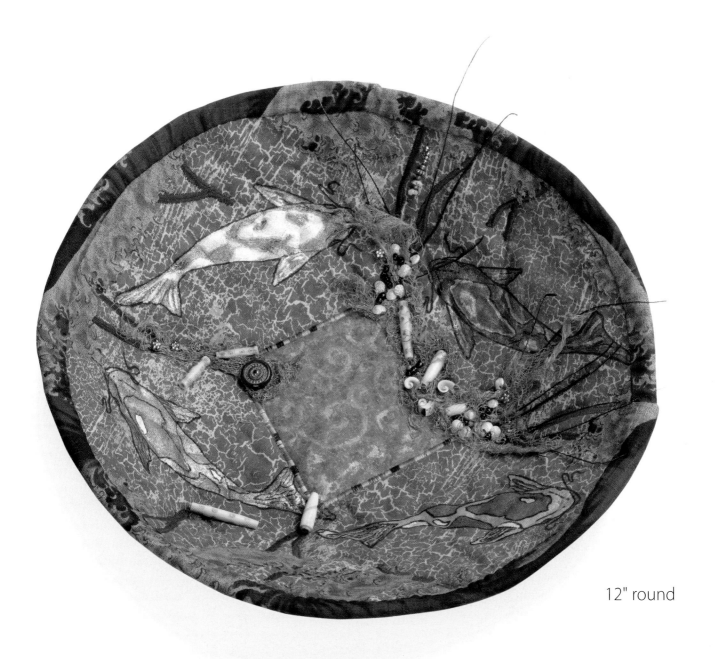

12" round

Waiting for Spring

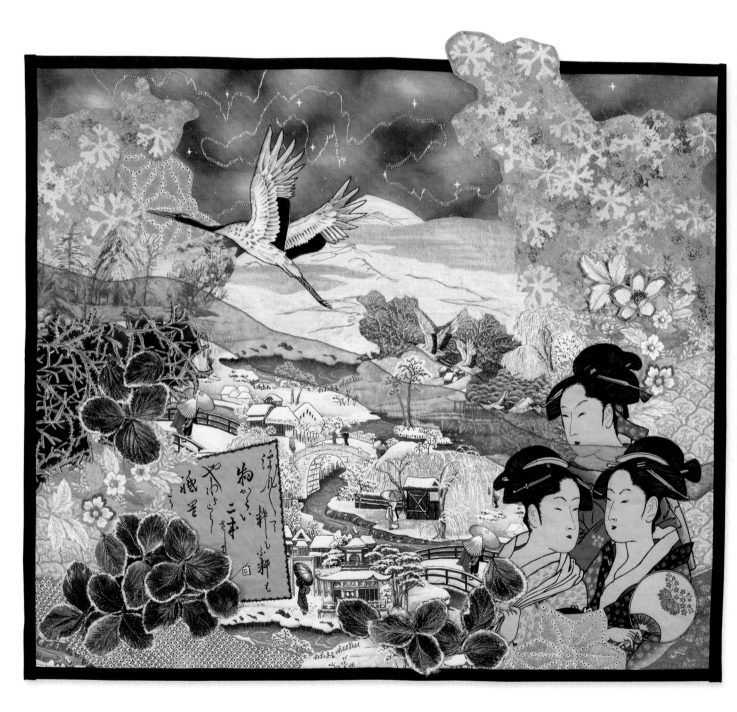

27" x 31"

Laura Jennings

*T*his piece is collaged using fourteen different fabrics, both cotton and silk. It is heavily stitched using free-motion techniques and decorative stitches, then embellished with beads. There are several three-dimensional elements as well. It was inspired by the cotton print depicting a winter landscape which is based on a traditional Japanese woodblock print by Hiroshige.

Laura Jennings has been creating with needle and thread for as long as she can remember. First there were cross-stitched samplers, then garments, which became more complex over time. Eventually quilts became part of her creative repertoire. Sometimes quilt inspiration and garment needs merge, and quilted, embellished garments come waltzing out of her cozy studio in Eugene, Oregon.

Laura finds inspiration in many places, but the most common influence on her work is the diversity of human culture. Although her degree in anthropology from the University of Oregon never landed her a paying job, it has been a rich source of creative ideas. "When representing a culture in my work, I strive for cultural authenticity over artistic license," she says.

And, always, there is color. She loves color. She's fascinated by the effect that colors have on each other when used in various combinations. Equally fascinating is how people react to various colors and color combinations. Laura comments, "this can lead back around to my original curiosity with human culture because our likes and dislikes are so often tied up in cultural biases." It can be a great experiment to create in colors that she knows will evoke a reaction— positive or negative.

Laura has won several awards and been in juried as well as group shows. Her quilts have been exhibited in shows from Oregon, to Paducah, Kentucky and traveled to shows as far away as Seoul, Korea and Rouen, France. She has been published in Les Nouvelles du Patchwork and Threads Magazine. Her works are in several private collections and she has taught and spoken to guilds and groups on subjects as varied as free motion stitching to silk ribbon bobbin work.

…quilted, embellished garments sometimes come waltzing out of her cozy studio in Eugene, Oregon.

Marjorie is a fiber artist working with the color, pattern and texture of fabric. She enjoys the freedom, movement and power given to creating the sculpture of cloth. Her wall pieces are sometimes landscapes that depict a story of travel or record the passage of time. Some wall pieces tell stories and some are a puzzle piece waiting for the viewer to solve. Marjorie likes to hide little surprises in each piece to give the work extra meaning. The wall hangings tend to be three dimensional and ask the viewer to enter into and touch the world shown.

This talented fabric artist likes to mix cotton, silk, metallic, rayon, sheers and wool fabric to achieve the effect she's looking for. Adding things such as brass trinkets, tin shapes, glass beading and silky ribbons add interesting accents to her pieces.

Marjorie lives in Modesto, California. Her quilts have been exhibited in galleries around the United States as well as numerous quilt shows. This year she will be painting a cello as part of a fund raising project for the Modesto Symphony Orchestra.

The skyline of San Francisco starts the adventure at the top of this interesting wall piece. The mountains around the city by the bay watch over cable cars, music, tourists, dancers, museums, condos, traffic, different ethnic neighborhoods and letters home about California. Floating dancers lead the way to Hollywood, movie theaters, Disneyland, antique cars, actors, robots, coffee shops, city hall and The Wizard of Oz.

To design this piece, Marjorie started at the top with sky, clouds and some mountains. The fabric on top is the bottom fabric layer. She layered fabric as she went down, one on top of the other. The bottom fabric piece is usually the fabric that is on the top of the layering. After she layered the fabric to tell the story of the landscape, she went back and inserted sheers. This was done to create atmosphere and give depth to the landscape. She then began sewing the fabric with a mixture of horizontal and vertical rows of stitching. The horizontal stitching gives a feeling of height. The vertical stitching shadows the contours of each fabric that is stitched vertically. At last, she stitched the piece at the bottom of the landscape, then everything was sewn down. To finish the piece, Marjorie added a narrow border and then a wider border.

Marjorie likes to hide little surprises in each piece to give the work extra meaning.

California, North to South

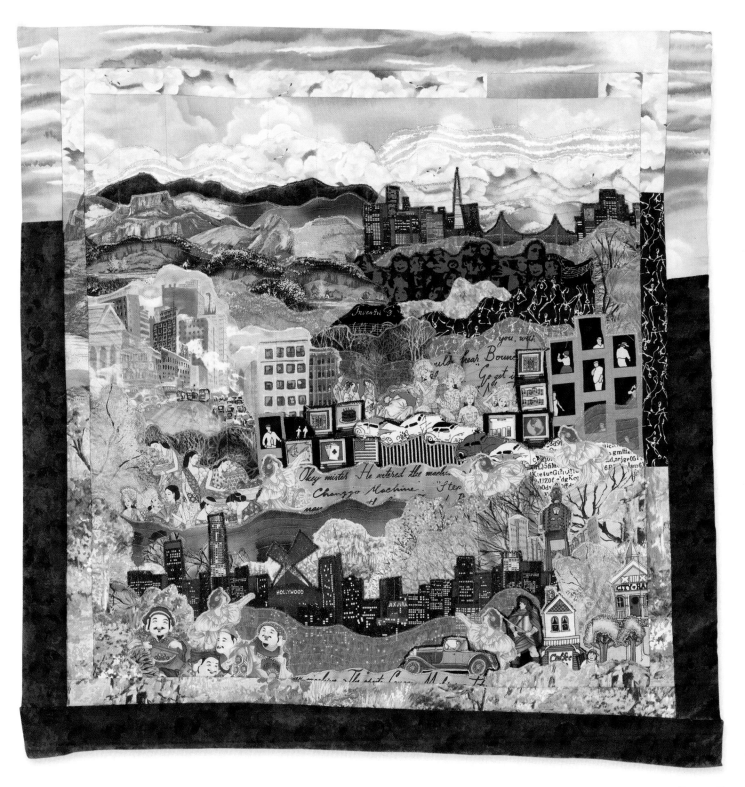

26" x 30"

Seeing Red

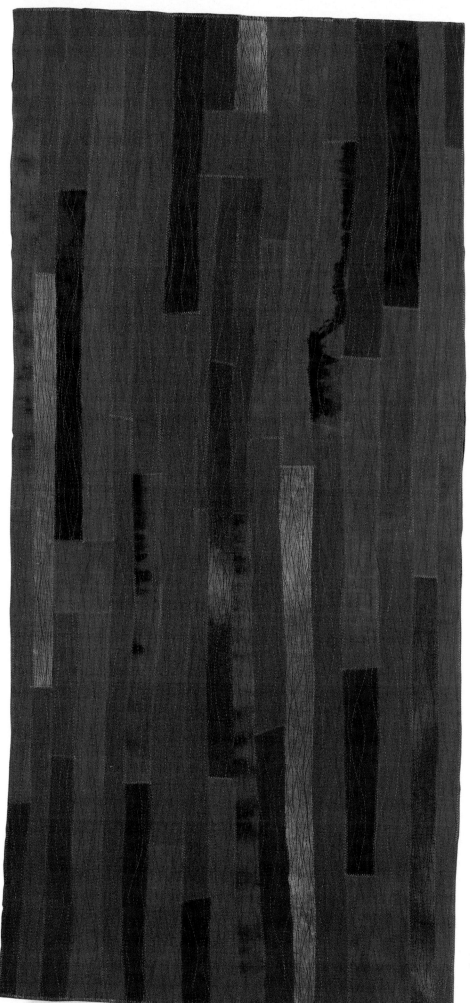

22" x 47"

Phil D. Jones

This piece is the fifth in Phil's Passage Series. It marks this body of work's standard for artistic inquiry, beginning with monochromatic reds. "Seeing Red" features his signature hand-dyed and discharged/over-dyed shibori fabrics. The fabrics are dyed repeatedly to achieve their full depth of color and complexity. After extensive stitching, it was processed to shrink, lending the look and feel of what he terms a "future artifact."

Having learned to sew on his grandmother's treadle sewing machine when he was five years old, Phil pursued clothing construction starting in his late teens. His interest in art began in his teens when he was an exchange student in Europe. It was natural for him to make the transition to quilting as an expressive medium in adulthood. His current interest in quilting began in 1990 when he made several panels for the NAMES Project AIDS Memorial Quilt. He then began making art quilts—intended as wall hangings as opposed to the more traditional bed quilt.

Phil is a veteran in the art quilt world showing in various well-known venues such as Quilt National in Athens, Ohio; Quilt 21, Lowell, Massachusettes; Art Quilts at the Sedgwick, Philadelphia, Pennsylvania; and Crafts National, University Park, Pennsylvania.

His works are currently on exhibit in the U.S. Embassy, Bridgetown, Barbados; and the U.S. Ambassadorial Mission, Pristine, Kosovo and are part of many public art collections including embassies, convention centers, medical centers and banks as well as many private collections.

He has been featured in American Craft, Fiberarts, Quilter's Newsletter, Surface Design Journal and Quilting Arts magazines.

Phil's work displays his influence by the Western art world, as well as through his studies of Eastern Asian and indigenous art forms. He employs various surface design techniques, including hand-dyeing and painting and a combination of hand and machine methods utilizing a variety of textiles and fibers.

This very talented artist lives in Denver, Colorado where he pursues his art career full time.

Phil's work displays his influence by the Western art world, as well as through his studies of Eastern Asian and indigenous art forms.

Peg Keeney

Artist, Peg Keeney's work invites people to come closer and enter her world to discover its mysteries and intricate beauty. Hours spent observing and studying the various moods and faces of the woods around her are recorded in beautiful details or colorful abstractions of the natural world of the northern forest.

Peg works intuitively, building each piece like a collage, but using the basic elements of a quilt. Her canvases combine hand-dyed, commercial, stamped, painted fabrics, digitally altered photographs, and a variety of embellishments until she achieves her vision. The sensuous surfaces and rich colors beg the viewer to "feel" the energy that radiates from her work.

Peg began working full time as an artist in 2001. She lives in beautiful Harbor Springs, Michigan, where, as she states, "the deer and the coyotes roam." As a trustee on the board of the Michigan Nature Association, she works to preserve and protect examples of Michigan's unique landscapes.

"Fantasy #3" began as a memory of a spring walk in the forest. Peg chose hand-dyed silks, cottons and commercial fabrics from her stash, some unusual papers, and a handful of assorted yarns and a photograph. She made a photo transfer, then layered transparent material over the photo and began to add fabrics and additional layers that recalled the vibrant spring greens of the woods. Here and there she added surprise bits of color that one would encounter on such a walk. Next, she added yarns to help the eye move across the surface. At this point the work seemed to call for some element that would tie it together, so Peg added a strip of Japanese calligraphy. Finally, she free-motion quilted it using a variety of rayon threads.

Peg Keeney's work invites people to come closer and enter her world to discover its mysteries and intricate beauty.

Fantasy #3

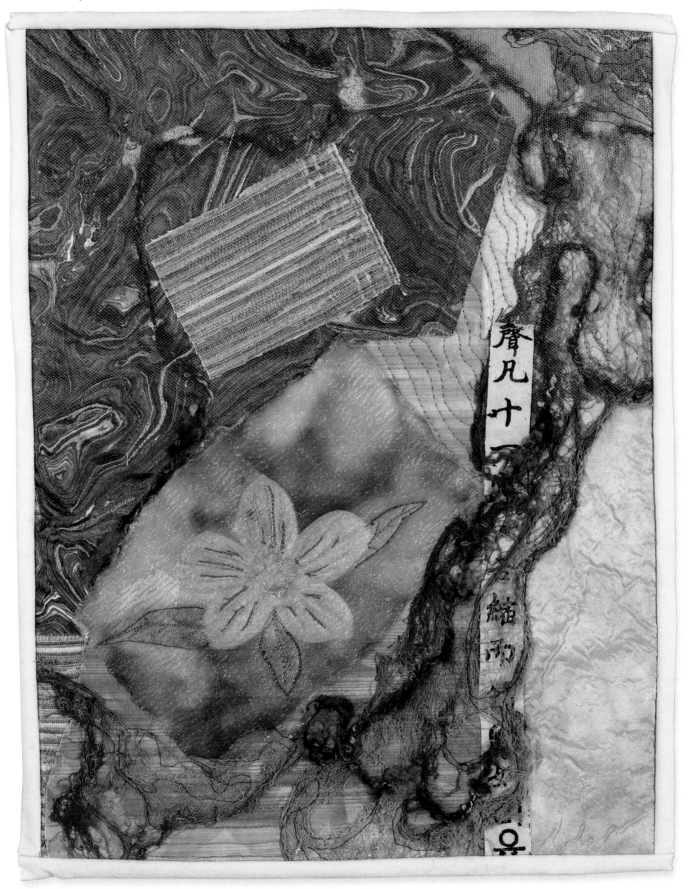

11" x 14"

Seek

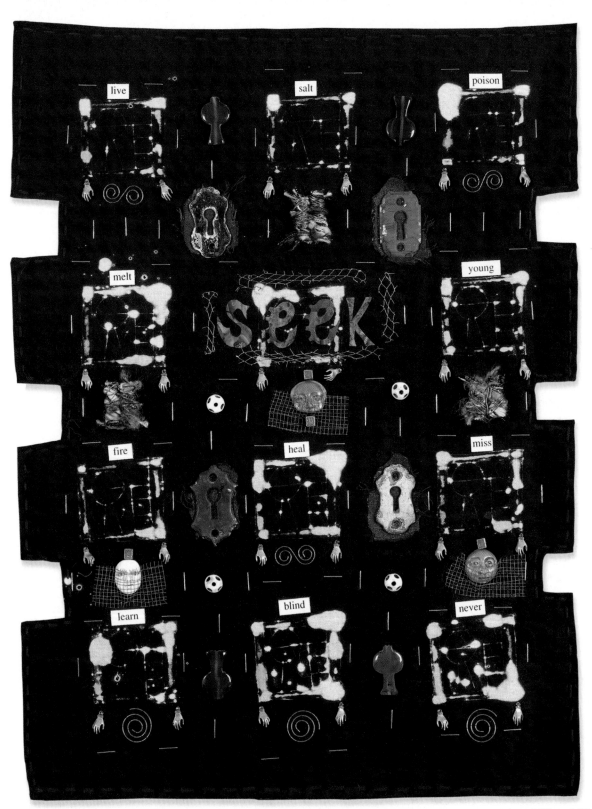

live salt poison
melt seek young
fire heal miss
learn blind never

15" x 19"

*S*eek is a mixed-media art quilt. The background fabric is discharge dyed. It has several elements for embellishments—fabric beads (made by Lynn), keyhole plates rescued from an old Victorian home, polymer clay faces, and various beads. The clay faces are shielded by a web, showing the reluctance sometimes shown toward the unknown of the future. Keyholes are waiting to take us to different worlds. Random words are scattered above each section. The staple quilting shows the structure that we build over time to hold the layers of lives together.

Lynn Krawczyk

Lynn began creating fiber arts in 2000 after back surgery. During the long months of recovery, she filled her time with Victorian crazy quilting. This led to a fascination with art quilts and art dolls.

She takes much pleasure in producing mixed-media art pieces by adding in sounds, textures and touch that are uncommon to traditional quilts. They serve as reminders that the piece being viewed is an insight to the artist and not just a mixture of material items.

Lynn has been published in Soft Cloth Dolls and Animals and was recently awarded first place in the Canadian Doll Artist Association competition. She participated in A Fiber Arts Invitational Project in Novi, Michigan and the 2005 Michigan Quilt Invitational and 2005 Journal Quilt Project for the International Quilt Festival.

She divides her time between her fiber arts store, Lost Arts Stitchery in Plymouth, Michigan and her successful career as an automotive engineer!

Hope

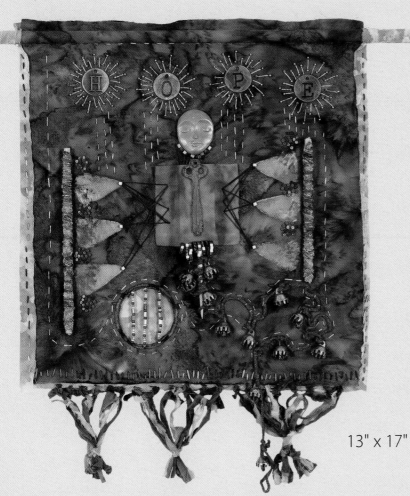

13" x 17"

Hope

The mixed-media art quilt "Hope" includes several different elements such as a clay face, porcupine quill, string of prayer bells, antique key, beading and embroidery. The figure in the piece is anchored by dowels on each side, acting as shields. The porcupine quill symbolizes the harshness of the situations that often lead people to turn to hope. The prayer bells show that tranquility can eventually overcome this harshness. A window cut from the background fabric exposes the release that hope offers.

Pat Kumicich

Pat Kumicich is known for her award-winning art quilts, which are easily recognized by their vibrant colors. Her works have appeared in numerous exhibitions and publications throughout the United States and many of Pat's quilts hang in private collections in both the United States and Europe.

Fiber of any kind has always been an interest of hers. She began quilting in 1994 at the suggestion of her daughter, Jennifer. She's self-taught and enjoys experimenting with different techniques, fibers and threads. Many of the fabrics she uses are hand-dyed. She often embellishes her quilts with hand-beading.

Pat is constantly striving to grow in this artistic endeavor. Her work quite often is inspired by women that she knows or imagines. She particularly enjoys exhibiting her quilts to share with others. Besides quilting, Pat says, "I enjoy making art dolls and painting anything that doesn't move."

Pat and her husband, Richard, live in Naples, Florida. They have four children and seven grandchildren.

This whimsical design was made of hand-dyed cotton fabric using Diazol direct dye. The want-ads were scanned into the computer and then printed on the fabric. The quilt was foiled, fabric painted, and stamped. Beads, sequins and decorative paper clips were used as embellishments. The piece was machine-appliquéd, machine-pieced and hand-quilted.

> ## Her work quite often is inspired by women that she knows or imagines.

28

What is a Girl To Do?

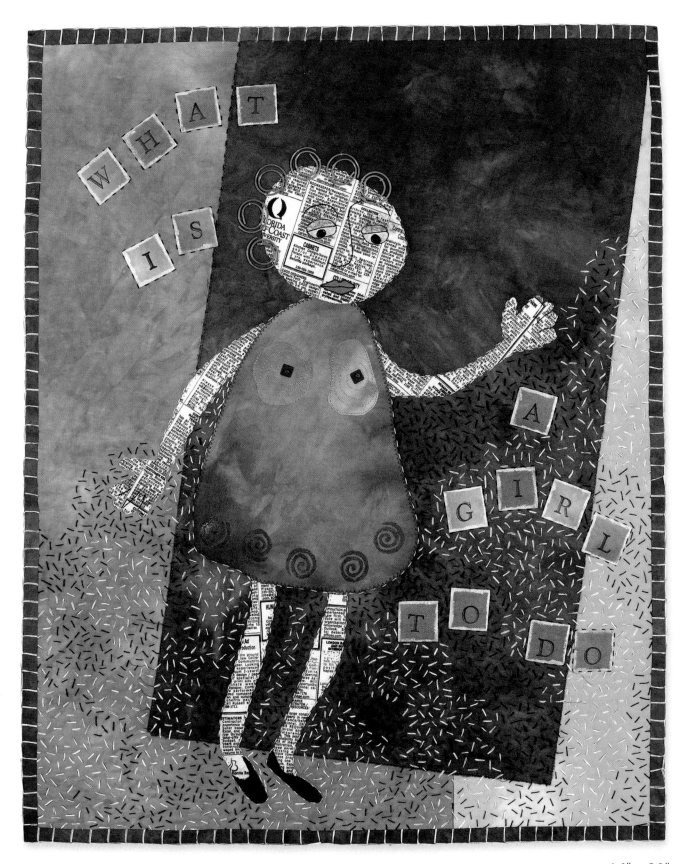

16" x 20"

Striae 2

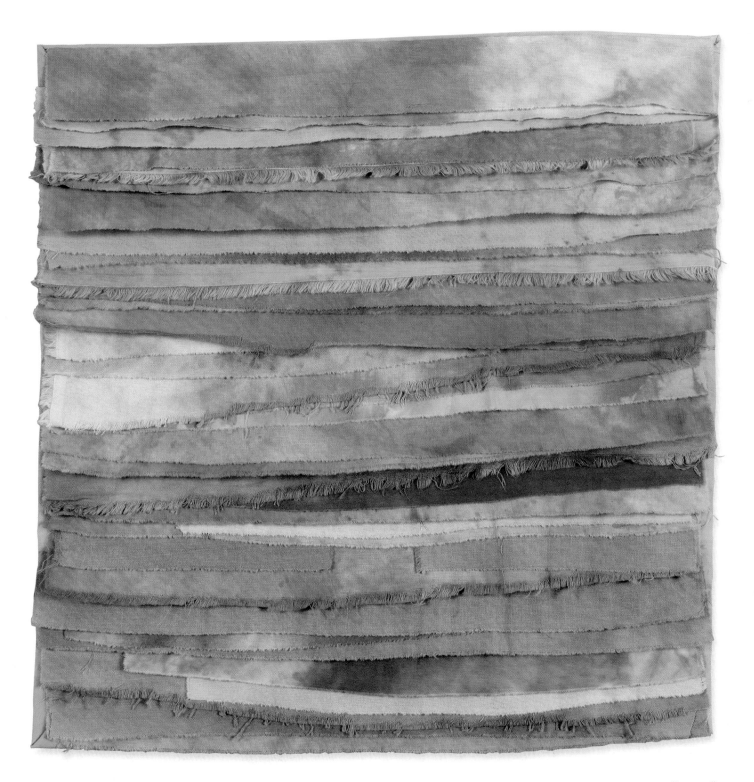

15" x 15"

Deborah Lacativa

"Striae 2" is the second in a series of pieces that showcase the subtle variations possible using hand-dyed cotton muslin and selected metallic synthetic fibers. "Unlike some fiber artists, I always enjoy hand work. So while my sewing machine went into the shop for repairs, I began building this piece with the thought of using the fabric in an almost sculptural manner, using the least amount of traditional sewing tools and techniques," she said. The strips were torn by hand, painstakingly organized and then hand-stitched into place leaving the raw edges of the fabric to lift and fray. The changing play of light and shadows added to the sculptural element of the work. "I plan to do larger pieces using the same techniques, but for the sake of time, I'll use the sewing machine for the assembly stitching which, after all, is hidden in the construction of the work," she stated.

"I often have no idea what's coming when I sit down to sew, I let the fabric lead the way."

With a background in painting, Deborah Lacativa's design approach to textile art is far from the beaten path of traditional quilters. She attended the School of Visual Arts in New York, where she learned the basic principles of design. With a natural aversion to instructions, rules, recipes or guidance of any sort, she is largely self-taught. Although she did learn basic sewing skills from her grandmother, Nellie Farrington and her aunt, Ellie Mercurio. Like many quilters, her first quilts were made for her two children.

"In the beginning, my focus in quilting was utility. Quilts were used for warmth, to recycle old fabric, and if I was very lucky, beautiful to look at." It wasn't until recently that she combined her love of color and abstract painting techniques with textile art. " I often have no idea what's coming when I sit down to sew," she states. "I let the fabric lead the way." Deborah dyes her own fabrics and is currently working with a variety of re-cycled and antique cottons to achieve a unique palette of colors and textures for her work. Everything she makes now is about having a good time, exciting the eye and engaging the viewer.

Jane LaFazio

Jane calls herself a mixed-media artist. She loves being a creative soul, and doesn't want to limit herself to just one medium or artistic direction. Not only does she make art quilts, she also paints watercolors and acrylic on canvas. Whether fabric, paper or canvas, you can see a common theme of texture and color in Jane's works.

She's inspired by the traditional folk arts and ancient icons of Mexico, Asia and Italy. She loves to travel and to discover new art techniques, unusual color schemes, and intricate patterns from other countries.

When she's not traveling, Jane makes her home in San Diego, California where she is inspired by the local trees, birds, fruits and flowers that she then incorporates in her pieces.

Jane was proud to be included as a featured artist in _Material Visions: A Gallery of Miniature Art Quilts_ published by Stampington & Company in 2004.

All of Jane's art quilts are hand-stitched. "Though labor intensive," she says, "I find the process very enjoyable, and almost like a meditation."

Jane is inspired by the traditional folk arts and ancient icons of Mexico, Asia and Italy.

Both of these pieces are hand-stitched and have been created of wool felt. The sequined birds adorn the branches of the tree of life. Little leaf charms dangle from the tree along with felt leaves. The other tree of life piece features Jane's kitty, Cool Baby and her precious departed, JazzCat with wings. Silver star charms decorate the sky and various beads and buttons add further embellishment. The edges of both pieces are blanket stitched. Heart charms are stitched to each as a finishing touch.

Birdies at Tree of Life

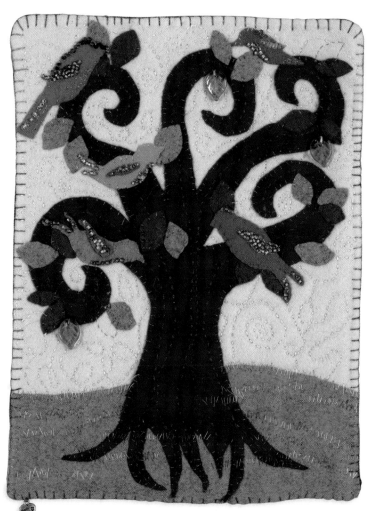

9" x 12"

Kitties at Tree of Life

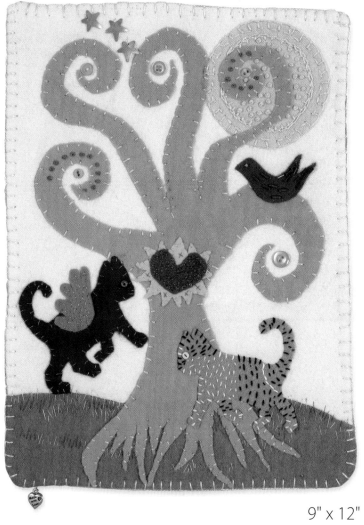

9" x 12"

Slivers 5

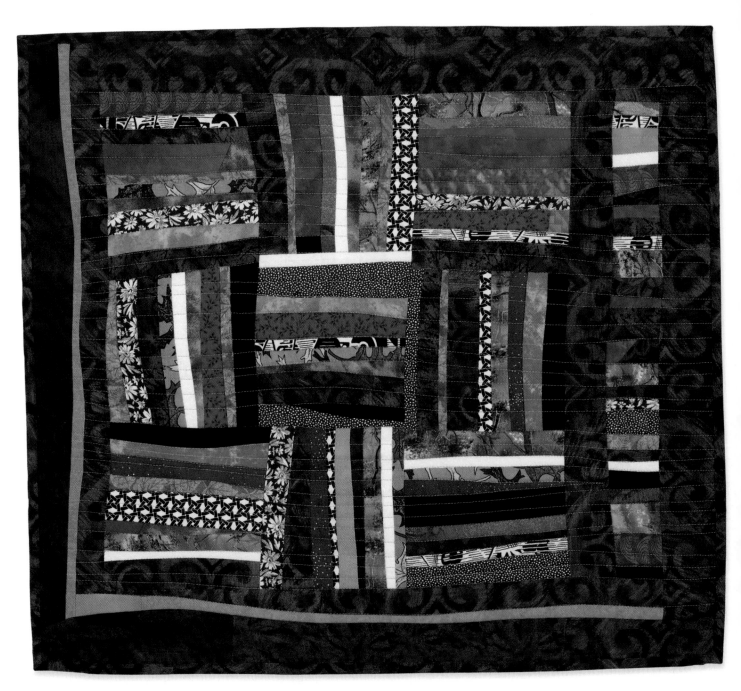

21" x 18"

Kathleen Loomis

Kathy has always hated to see small pieces of beautiful fabric go to waste, and typically sews scraps into small quilts. She's been fortunate to have many quilting friends give their scraps to her, too! Many scrap bags contain long skinny strips left over from trimming the edges of quilts or larger sections. She likes to stitch strips of the same length together into blocks, then assemble the blocks into patterns. This quilt pays homage to the traditional nine-patch arrangement.

If you sew several skinny strips together and then press the entire section at once rather than pressing each seam individually, the fabrics mold easily into curves. "I like the serendipity of the shapes that the fabrics choose for themselves," Kathy says. "I press lightly from the back, with all seam allowances pointed in the same direction, then turn the piece and press enthusiastically from the right side making sure all seams are fully open (no little areas hidden under pleats) and the section lies perfectly flat."

Kathleen Loomis studied history and journalism at Syracuse University and Northwestern University. She worked as a reporter for The Courier-Journal in Louisville, Kentucky, covering the environment and urban affairs. It was there that she met and married Kenneth, a fellow reporter. They spent three years living in Germany while he worked for the military newspaper, Stars and Stripes. They traveled throughout western Europe, but sadly could not go behind the Iron Curtain (except for a day trip to East Berlin) because the Soviets considered all military journalists to be spies, and refused them visas.

After returning to the United States, Kathy worked in a variety of jobs in journalism, public relations and corporate communication while her two sons were small. She worked for a consulting firm for 20 years. Kathy's job was to explain complex actuarial and legislative developments in non-technical language for the firm's clients and consultants.

Kathy has sewed and done handwork all her life and made traditional quilts for many years. Over the years she has amassed a huge collection of paintings, prints and sculpture, "I never thought of myself as an artist, because I couldn't draw, so I felt my role was to be an appreciator and patron of the arts. A dozen years ago I realized that I am an artist with fabric as my medium, and that has changed my life." Since retirement, she has worked full time as a fiber artist. Her works have been shown at galleries and quilt shows around the United States including Quilt National, Paducah, Houston and several Quilt Expos in Europe. She won the first annual Alma Lesch Award for innovation in textile art at the Kentucky State Fair in 2002.

"I never thought of myself as an artist because I couldn't draw, but a dozen years ago I realized that I am an artist, with fabric as my medium, and that has changed my life."

"Tomatoe" Love

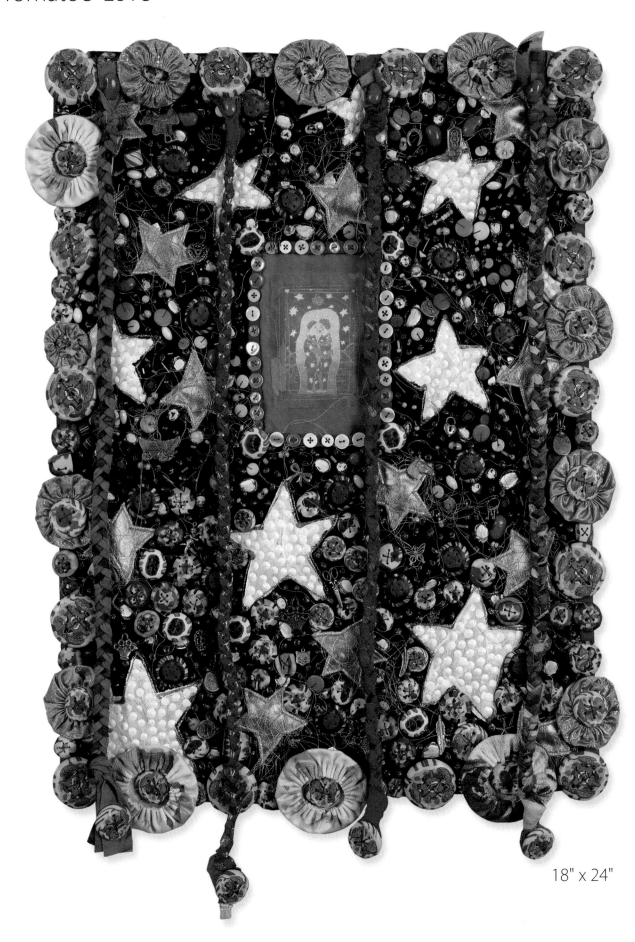

18" x 24"

Therese May

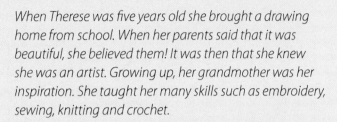

This piece began with a small drawing done in pen and ink and color felt tip pens. Therese made a screen of shear fabric over the small drawing on paper to protect it, like a piece of glass over a work of art being framed. From there she "built the frame" for the drawing. The frame consisted of painted and appliqued fabric, buttons, beads, polymer clay, charms and braided fabric. Sewing the various embellishments onto the surface of the piece forms stitching all the way through to the back of the quilt. This makes for the quilting of the three layers (the "sandwich")—the top, the batting and the backing.

When Therese was five years old she brought a drawing home from school. When her parents said that it was beautiful, she believed them! It was then that she knew she was an artist. Growing up, her grandmother was her inspiration. She taught her many skills such as embroidery, sewing, knitting and crochet.

She attended the University of Wisconsin majoring in art and later got her master's degree from San Jose State University.

When she was home with her children, Ian and Bridget, she started developing her art quilts, a combination of the skills taught by her grandmother and her art education. She's been making quilts ever since—40 years to be exact.

Therese May has been a leader in the creation and development of art quilting, recognized worldwide as a guiding light in the movement and one of its most inspiring advocates. Honored as both artist and teacher, she has been chosen to exhibit her works at the Smithsonian Institution in Washington and at the Louvre in Paris. Her works have been published in The Art Quilt and America's Glorious Quilts. She received "The Most Innovative Use of Medium Award" and the "Quilts Japan Prize" at Quilt National. She's taught at many schools and universities as well as numerous quilt guilds. She was commissioned to create two quilts for the City of San Jose—both 196 square foot works hang in the San Jose Convention Center.

Therese is a licensed spiritual counselor and is currently training to be a minister with the goal of practicing spiritual healing through art. She lives in San Jose, California with her significant other, Larry.

Margit Morawietz

Margit was born and raised in Germany. She discovered at a very early age that magical things could be done with cotton and wool yarn, and that an unassuming piece of fabric could be turned into an entity with a completely new character after "working it".

Her degree in textile design and fashion graphics and her experience in the fashion industry prove to be a strong foundation for her most important creative endeavor, art quilts.

Margit is always experimenting with new ideas including painting and exploring the intricacies of shibori, an ancient Japanese resist-dye technique. Many of Margit's pieces have been exhibited at shows and galleries nationwide. Recent successes include the shows at the Shemer Art Center and the Herberger Theater Center in Phoenix as well as the "Quilts: A World of Beauty" show in Houston, Texas. She has also received numerous awards at the World Quilt and Textile exhibition and Judge's Choice and Machine Quilting awards at the Arizona Quilting Guild show at Arizona State University West. In 2000, she was awarded a scholarship from the American Quilter's Society. Her work has been featured in Quilter's Newsletter Magazine and Belle Armoire. Margit lives in Phoenix, Arizona with her husband and their two dogs.

She discovered at a very early age that magical things could happen— that an unassuming piece of fabric could be turned into an entity with a completely new character.

(See page 40 for Margit's completely different take on an art quilt.)

This piece is part of a series of wall hangings which emphasize tactile contrasts. It's machine-pieced and quilted and includes fabric origami. Where the shadow-stitching of the olive cotton and the purple silk produces only a softly ridged surface, the black band is highly three-dimensional. Strips of fabric are sewn together to form a red and black striped unit. This unit is then folded and ironed into place to create a series of inverted pleats, with the black fabric appearing on top. After cutting the layered piece into the desired wavy shape, it is stitched to the two top and bottom pieces. The edges of each black strip are folded over and are touching each other in the middle of the strip, secured, so that the red fabric underneath is exposed.

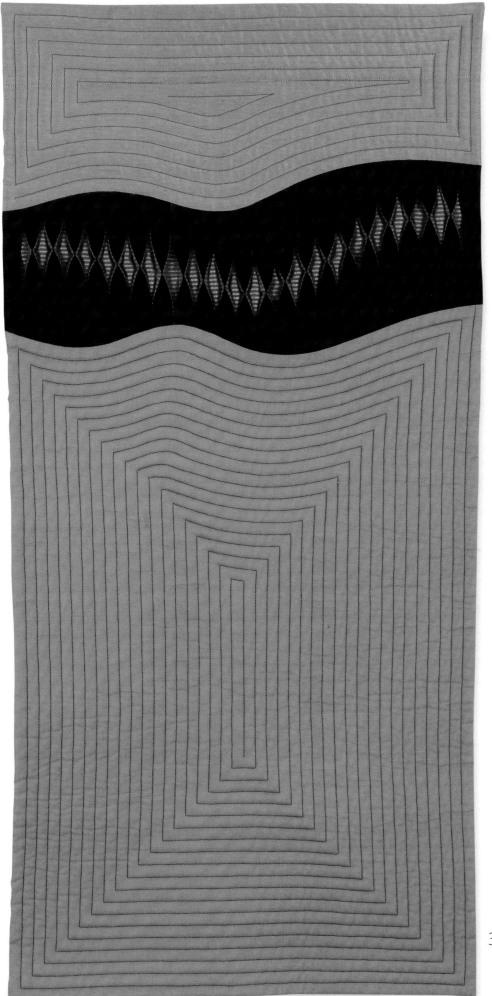

Red Wave

35¾" x 17½"

Frazzled

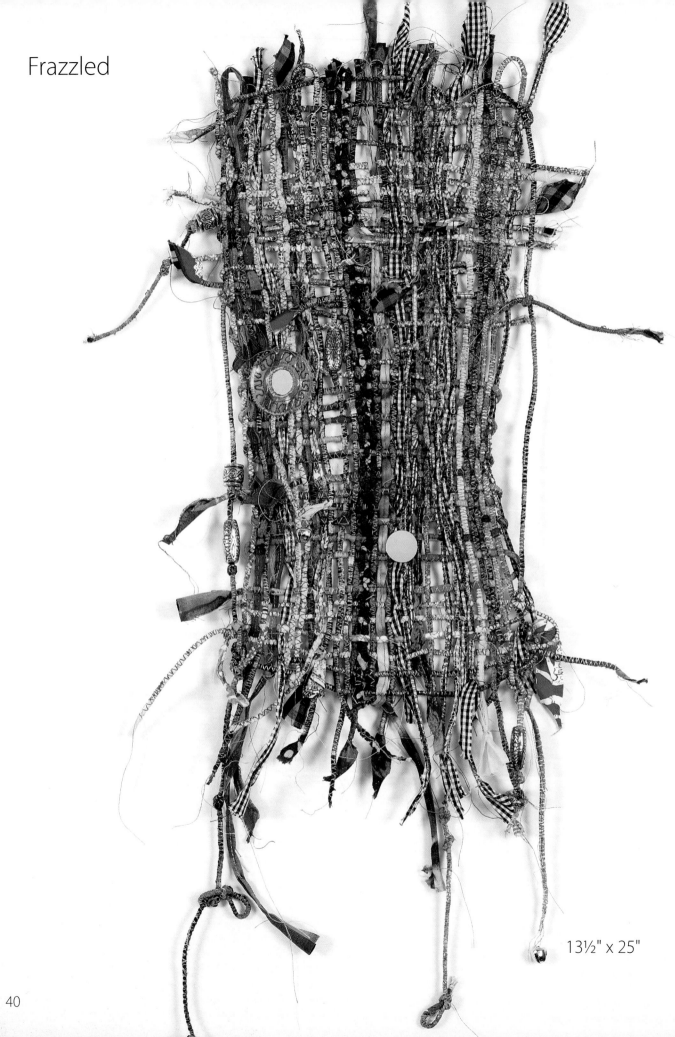

13½" x 25"

Margit Morawietz

The idea for this project came at a point in Margit's life when she felt pulled into a million different directions. The cords were made using commercial and hand-dyed fabric strips. Each strip was covered with a variety of rayon and metallic threads using a braiding foot and a loose satin stitch. Margit said these cords symbolize her frayed nerves. The cords were then hand-woven into a fragile net with ends sticking out and shisha mirrors and beads attached. It was fastened with buttons at the four corners to a machine-stitched sandwich of hand-dyed cotton poplin, batting and backing.

Margit said these cords symbolized her frayed nerves at a point in her life when she felt pulled into a million directions.

*E*dna is a life-long resident of East Saint Louis, Illinois. She is a graduate of Southern Illinois University-Edwardsville with a bachelor of fine arts and master of fine arts in studio art/fabric design, and a master of art in art therapy. Her art has been published in numerous books, catalogs and other media. She has been included in a number of galleries and museums internationally and in the United States. She has had over sixty solo, group and traveling exhibitions and appeared on a variety of television shows.

She, along with Rose Jackson Beavers, authored a book entitled Quilt Designs and Poetry Rhymes. The book includes beautiful art pieces and poems about life.

Besides creating fabric art pieces, Edna is also an art therapist and mental health coordinator.

The 23rd Psalm came to Edna in a dream. For about a week she would dream about some of the words in the Psalm. Finally, she got up in the middle of the night to read the entire verse, then images began to appear in her mind. Thus began the birth of this project. She worked the idea of the quilt as a large puzzle, taking specific words to address each section. For example, in the beginning "The Lord is My Shepherd" evolved into the image of the shepherd. After working on individual sections, she laid them out to decide how to make them work together. The person in the heart is symbolic of all people in spiritual need.

The 23rd Psalm came to Edna in a dream. Thus began the birth of this project.

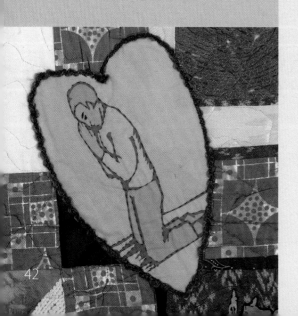

42

The 23rd Psalm

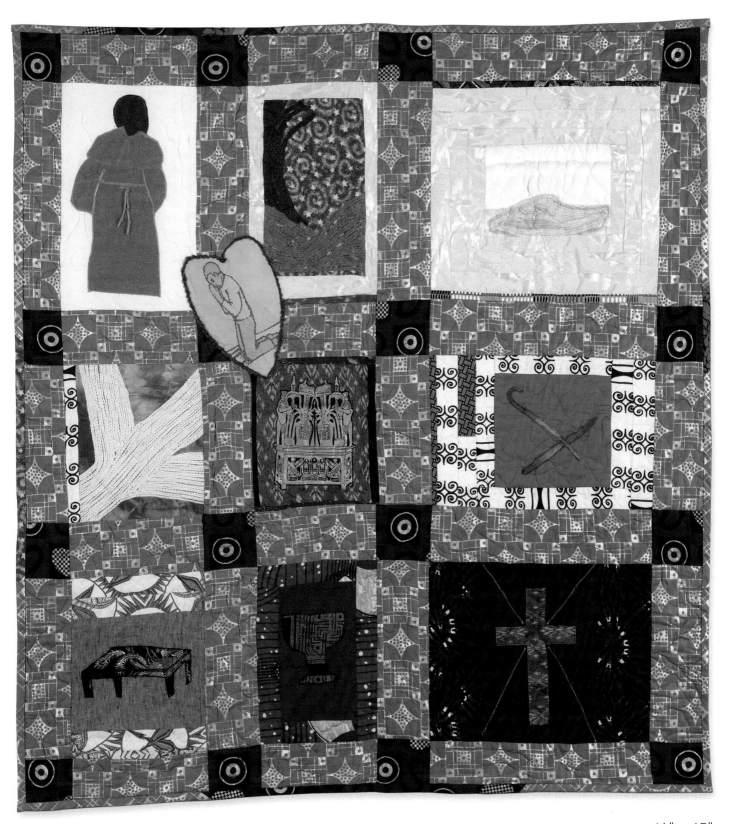

41" x 45"

Letters

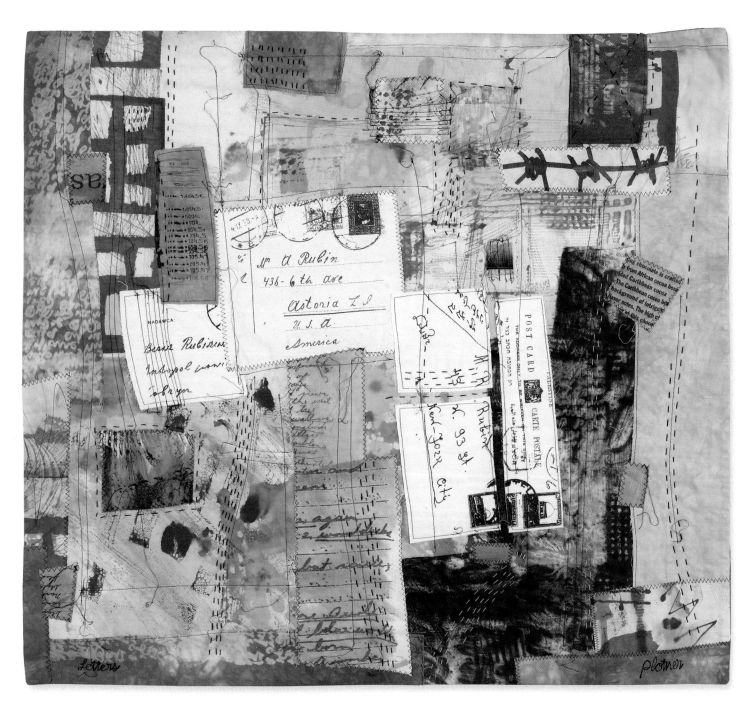

28" x 31"

Judith Plotner

This piece represents letters received by Judith's grandmother from Europe somewhere around the period of World War II. Judith begins her piece with an idea but usually not a sketch. She assembles a large group of fabrics which she has dyed, monoprinted and painted. Then she does a lot of printing on top of these fabrics, both photo transfers and rubber stamps. She begins moving them around on her design wall. When she's finally satisfied with the design, she photographs it with a digital camera, takes the pieces down and begins the assembly process. It usually changes as she's working on it. Her work is improvisational, working in a kind of stream of consciousness, using symbols that often seem disconnected but do relate in some way in her mind.

This piece represents letters received by Judith's grandmother from Europe somewhere around the period of World War II.

Judith was raised in New York City. She studied art at the City College of New York. When she and her husband bought a 100 year old farmhouse it had a wonderful old bed that they lovingly restored. "I thought...this bed needs a quilt," she recounted. And that was the beginning. She combined her lifetime of art experience into creating fiber collages.

Judith has exhibited widely including solo and group shows. She has been published in the books *Fiberarts Design Book 7* and *Stamping with Style* both by Lark Books, as well as publications such as *Art Quilt Magazine* and *Fiberarts*.

She has three children and three wonderful grandchildren. She now lives in the north woods of the Adirondack mountains with her artist husband and their cat.

Wen Redmond

Working with fabric, color, and texture has always been a source of jubilation for Wen Redmond. She manipulates and dyes natural fiber to create innovative assemblages on her art quilts and one-of-a-kind wearables. "I seek to tap into levels of myself and when I teach, to help others do the same—to reach deep inside and bring up... ourselves," she says. She is focused on the materials she works with and creates intuitively. Each piece seems to have an expression all its own, with Wen acting as the facilitator. Her works begin as an idea from nature or a dream, a treasured moment or insight. Thus inspired and wrought with joy, they become real. As Wen says, "a sweet fruition of spirit."

Wen lives in Strafford, New Hampshire. Her works have garnered many awards and have been exhibited nationally. Her pieces have appeared in many publications including Quilter's International and Fiber Arts Magazine.

This piece was created using hand-dyed, painted and surface-design techniques. The surface designs Wen usually uses include dyeing, painting, monotype, sponging, stenciling, stamping, image transfer and sun printing (cyanotype). She uses an original intuitive curved piecing technique with lots of creative stitching.

Her works begin as an idea from nature or a dream, a treasured moment or insight.

Metamorphosis

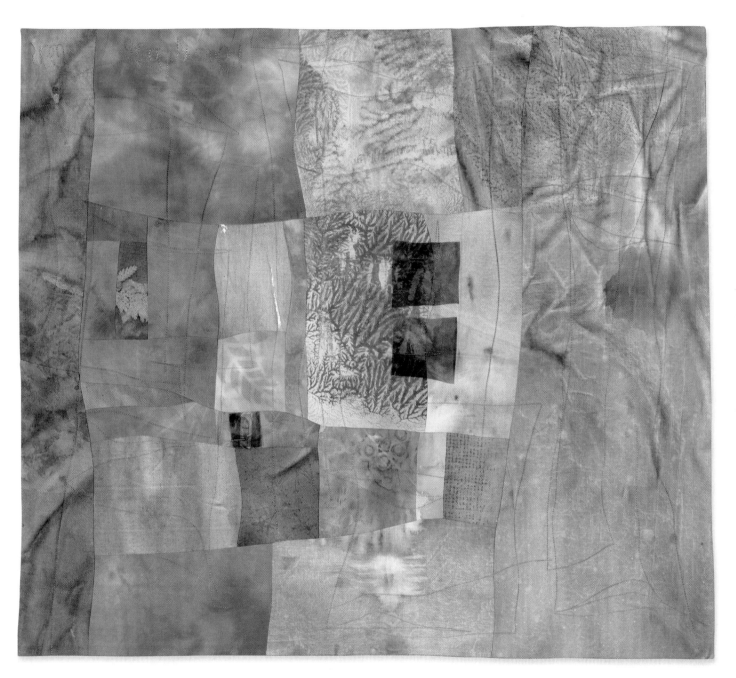

29" x 25"

Lesley Riley

*L*esley began making traditional quilts in 1970. At that time she became fascinated by the emergence of art quilts, but lacked the confidence to try one on her own. 25 years passed and in the meantime, she received enough art training to give her the confidence to trust her own vision. When she turned 40, she realized that she was on a journey of discovery. *"The more I learn", she says "the more I want to know".* She believes that her voice is just beginning to emerge in her quilts. Each quilt that she makes gets closer to expressing what she wants to say. She is constantly amazed that she has the opportunity to accomplish her dreams through art. Lesley's goal is to share what she has learned so that others may begin or enrich their own journey through life.

Lesley says, "My art is about the magic of making art...the how, the why, the what, even the where has unending fascination for me." Her work reflects her life. Her family is always present in her art. Art is a way of life in her house. She teaches her children what it took her 40 years to discover—that creating, making art, is a natural free-flowing process that requires no special time, no secluded space, no masters of fine arts degree.

Ms. Riley lives with her family in Bethesda, Maryland. Her book *Quilted Memories* was published in April, 2005. She is the art editor of *Cloth Paper Scissors.* She has been exhibited nationally and received many awards for her work.

Chic

This is Lesley's take on strip-piecing and the scrap bag quilt, what she calls a "trash can quilt". When she glanced at the scraps in her trash can, they all seemed to be in the same color family. These glittering jewels said, "we're not trash, we're treasure." This became a challenge—to use every fabric that was in the trash. It's a game that she plays, getting weird fabric to work together by balancing the color, pattern and amount of use. Lesley plays this same game in life—seeing what the day has to offer and figuring out how to balance the good with the bad so that it all flows well and has a positive outcome. "Sometimes coming up with a positive result is darn difficult," she says, "not all of the results are successful, but at least I tried and I can feel good about that."

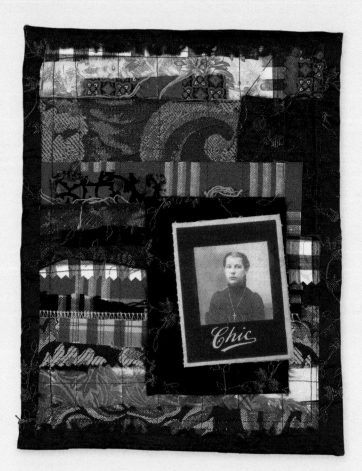

8½" x 11"

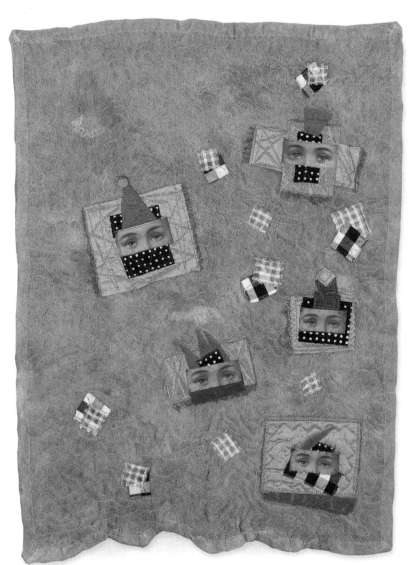

Inside Out

"Inside Out" was an exploration of quilt layers. Lesley took a felting class and learned a technique called Nuno felt, which is light and thin and really beautiful. Using dyed roving, she felted the batting and made it the primary focus of the quilt. The quilt top and backing are organza. She appliquéd image transfers and dupioni silks either over or under the organza, sometimes inside, sometimes out (thus the name of this quilt). This piece is machine-appliquéd and machine-quilted. It challenges the viewer's traditional concept of quilt layers. It symbolizes the way we look at other people, often judging them by what is visible to the eye and failing to see the inner person.

17" x 23"

Orange

Lesley's sister noticed that she was using reds and oranges one winter. She discovered that she was going through different color periods, buying fabric in certain hues and obsessively using them in everything she was doing. Wanting to stretch herself, she decided to try something more random, but as usual, ended up with a very balanced, classical composition. Lesley confesses, "I find it hard to go outside my comfort zone. I feel like things don't look right when I do." She wonders if she's in a rut, or afraid to grow and is this just her style that she should stick to and let changes just come naturally. "I am more interested in conveying a mood and suggesting a story. I want to use fabric in unexpected ways to further my storytelling. Perhaps I should be writing!"

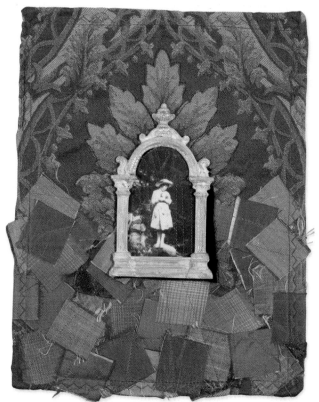

9" x 11"

Carpe Diem

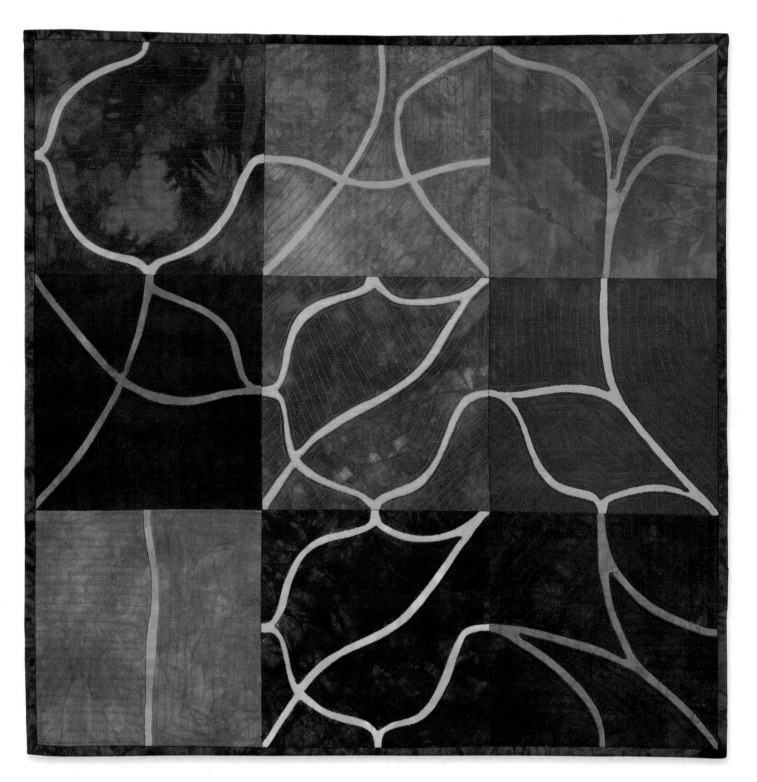

24" x 24"

Connie Rohman

Being interested in "line" as a design element, Connie incorporates words into the quilting of a piece. She's currently working on a series of line/language quilts, where the stylized letters intersect to form an abstract pattern that can also be "read". This piece reads "Carpe Diem", which means seize the day.

Connie dyes her cotton fabrics with Procion MX dyes, using a low immersion technique, dying half yard pieces at a time in plastic bags which gives it that mottled hand-dyed look. The colors of the Procion dyes are rich and saturated. For larger pieces of fabric, she uses the low immersion technique as well, scrunching three to five yards of fabric into the bottom of a large plastic bin, and then pouring the dye solution over the fabric.

Each letter block of this quilt is done in hand reversed appliqué. She layers two pieces of fabric, the size of the finished block plus seam allowances, chalks on the lines of the letters, then machine-bastes around those chalk lines. After that, she carefully cuts around the chalk line of the letter through the top fabric only. The edges are folded back and hand sewn down. The finished applique blocks are then machine-pieced together. The quilt is layered with a batting and backing, and basted. Connie uses an open toed darning foot to do hand guided machine-quilting.

Connie Rohman grew up in a remote Quaker community in the Canadian Rockies, in British Columbia. She now lives in Los Angeles where she works as a fiber artist. Connie's work, "Rhapsody in Blue," was awarded a first place ribbon in the Glendale Quilt Show 2000, received a special commendation from the Los Angeles Board of Education, and was displayed at the Los Angeles City Hall. Her works have been exhibited at the Lombardo Studios, Barnsdale Arts Center, Ruskin Art Club, the Discovery Tour of the Arroyo Arts collective, the Pacific International Quilt Festival, and Road to California Quilt Show. Her pieces can be found in private collections in the United States and Canada.

Connie's work is influenced by the landscape of her childhood, both interior and exterior. She creates fabric collage, fiber wall art and art quilts. She uses the traditional materials and methods of quilt making to explore abstract shape, line and color.

This piece reads "Carpe Diem", which means seize the day.

Rose Rushbrooke

Born in London, England, Rose has lived abroad since 1986. She first moved to Antigua in the West Indies and then to Virginia, USA. She met her American husband in the islands and relocated here in 1996. Her professional career as an artist began in the Caribbean where she made a living painting.

Her interest in modern fractal geometry led her to using these fascinating images as a starting point for her work. As she goes through the construction process, the meaning unfolds, in much the same fashion as one can read a picture in an ink blot or cloud. Her work is about personal experience and each piece is an entry into her journal of life.

Construction of her wall hangings is a mixture of hand and machine stitching. Natural and man-made fibers are incorporated. Using the traditional skills of piecing, appliqué, embroidery, embellishment and quilting, she takes pride in her craftsmanship.

Three Virginia art galleries sell her work and she exhibits nationally and internationally at both quilt and art shows. She has been filmed by HGTV for "Simply Quilts" and by Adelphia for "Artscape", appearing on TV for a combined total of fourteen minutes - she is still owed one minute of fame!

Rose decided to make this traditional quilt that had "gone mad with buttons". There are several open buttonholes to indicate that not everything is buttoned up.

This piece was made for the Self-Portrait book of the Q&A art quilters group. The original plan was to make small art quilts for people to touch at exhibitions and it evolved into very individual artwork that represented each member. As an English woman in America, Rose is often considered rather formal and conservative, so she decided to make this traditional quilt that had "gone mad with buttons". There are several open buttonholes to indicate that not everything is buttoned up. Rose usually works with 100% commercially printed cotton that she incorporates with her own hand-dyed fabrics. The piecing is done with fine cotton or cotton covered polyester. The piece is embellished with an assortment of buttons from Rose's personal collection.

Not All Buttoned Up

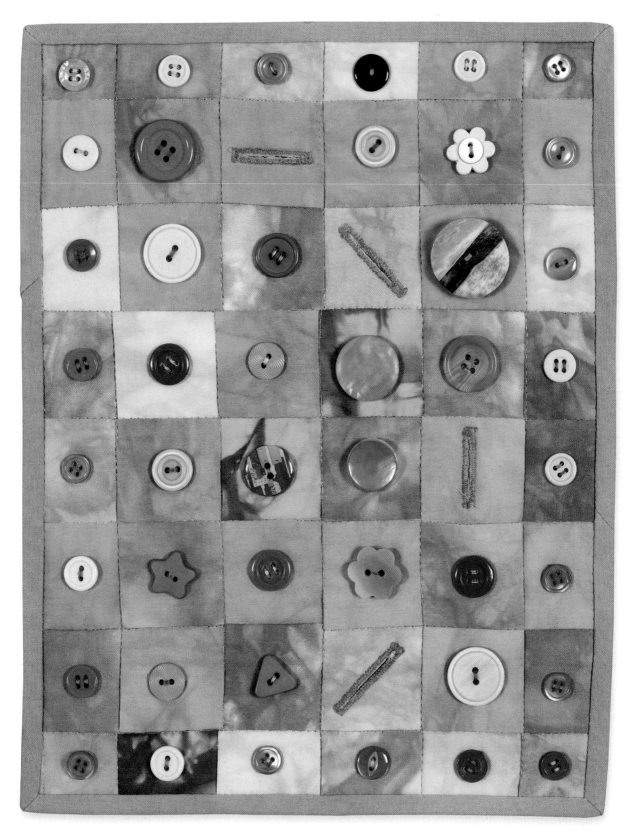

8½" x 11"

National Geographic

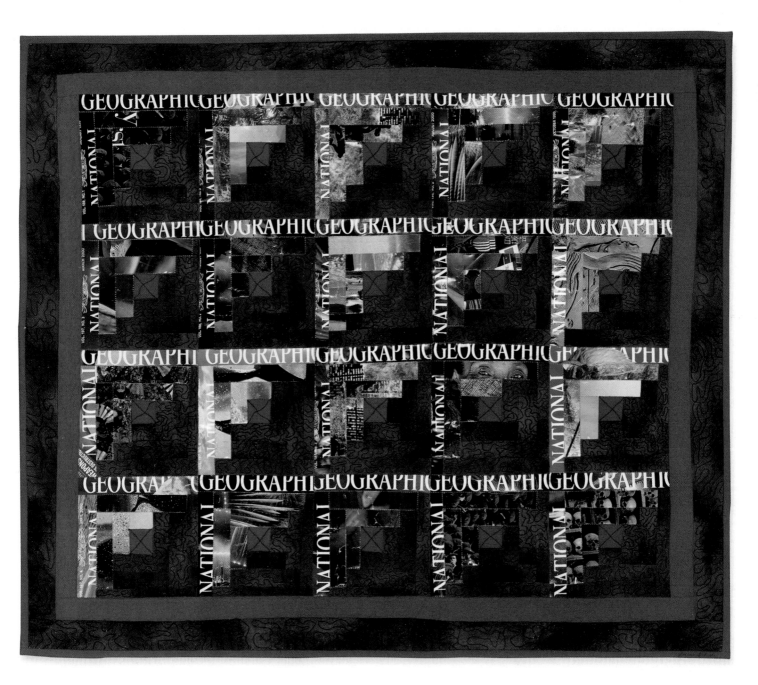

30" x 26"

Louise Thompson Schiele

The idea for this quilt came to Louise as she watched her stack of <u>National Geographics</u> multiply. She likes using uncommon things in her pieces, so she thought, "why not use my magazine supply?"

Louise treated the magazine covers as if they were fabric. She said that because the covers were of such good quality, they didn't tear, even when folded.

She used 100% cotton thread for the machine-stitching. After the quilt was pieced together, she was even able to iron it using the cotton setting.

When she did the quilting, she stitched just on the fabric part of the quilt because she didn't want to add more holes to the paper.

From an early age, Louise used her hands to create. She was always interested in how things work, how things were put together. It's not surprising to see what she creates now that she's in her fifties. Louise has worked in fabric most of her life. At a young age she was encouraged to use the sewing machine to create her own garments. Coming from a houseful of women with a limited income, being able to sew your own clothes meant you had what you wanted—instant designer fashions. Louise was given professional sewing lessons by a professional seamstress and that experience gave her the basics that she uses today in creating her wall quilts. Louise loves to experiment with different techniques and always takes it a step further in creating her own style of craftsmanship. Self-taught in quilt making, she leans toward contemporary surface design, creating original images using techniques unusual to the craft, always making her machine quilting skills with great results. "Color and design are the most important elements to a successful quilt; the rest holds it all together."

Louise's advice to other quilters, "Create what comes from an experience, create what comes from a relationship, create what your own mind's eye sees."

Louise loves to experiment with different techniques and always takes it a step further in creating her own style of craftsmanship.

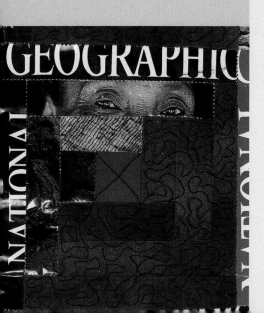

(See an example of Louise's versatility on page 57.)

Louise Thompson Schiele

Oprah Recycled

This quilt is in Oprah Winfrey's possession. It's a 20" x 26" uncommon but traditional log cabin piece. Louise used the front covers of Oprah's magazine along with 100% cotton to create this fabulous conversation piece.

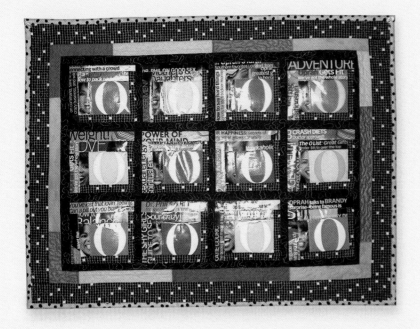

Louise machine quilted this 32" x 32" floral piece. The vase and flowers are hand-appliquéd to the background. Some of the flowers are beaded. The transparent layer of organza fabric, gives the illusion of a transparent vase.

Self taught in quilt making, Louise leans toward contemporary surface design, creating original images using techniques unusual to the craft.

Cut Flowers in Vase

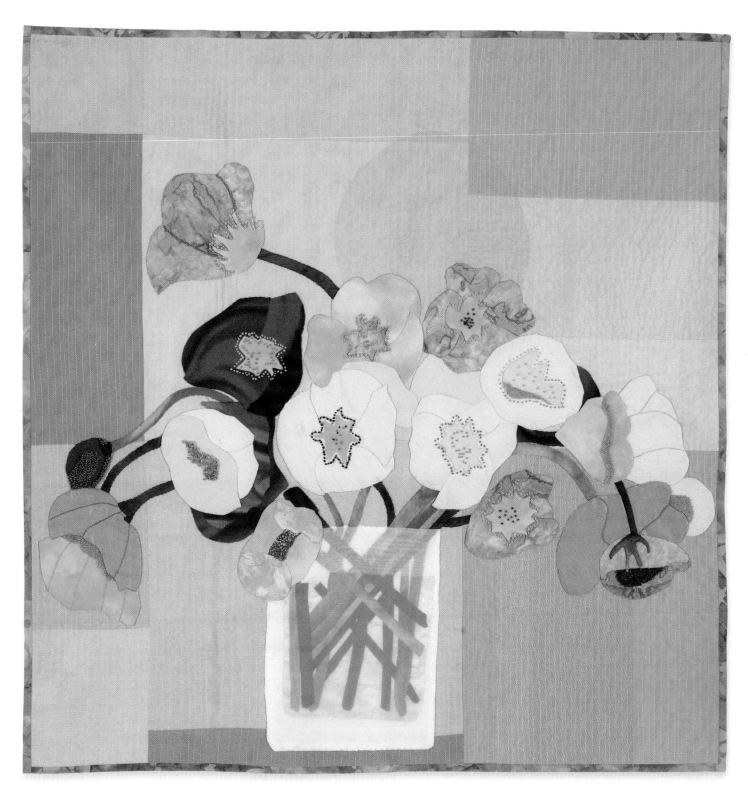

32" x 32"

Moon Rise

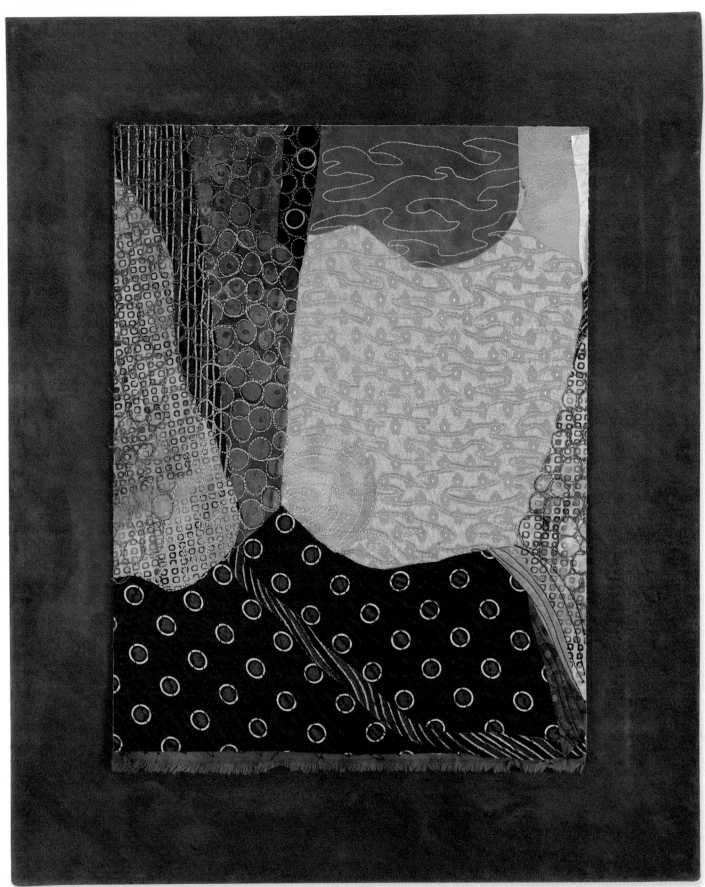

14" x 17"

Karen Smith

Karen says, "Sometimes I need a jump-start after being out of the studio for awhile." She picks out some of her favorite fabrics that look good together and irons a fusible web onto the back of them. She starts cutting and laying shapes down together, "waiting and listening for them to show me something." "Moon Rise" was started in this way. The fabrics were fused using light weight Wonder Under®, then machine-quilted and mounted on a stretched piece of purple suede.

Karen says, "I'm enjoying the freedom of fusing, and the freedom from traditional bindings."

Karen was raised in Galveston, Texas, the last of five generations of strong, proud women. She's happy to say that her parents are still in the area holding down the fort, or rather, the beach. Karen now lives in Nogal, New Mexico.

She enrolled as a freshman in college at 29 and went on to receive both her bachelor's degree in psychology and a masters of science in social work. After a brief career in medical social work and a three year stint with a debilitating illness, she reclaimed her grandmother's craft of sewing. She, her husband, Marvin, and three children moved to Lincoln County in 2003. She is now living her dream of making art under New Mexico skies. With the influence of a special friend, she has discovered fabric as her voice.

Karen is inspired by obvious things such as the color and pattern in a fine fabric and also by the more abstract ideas of spiritual living in this complicated world. Karen says, "Grace always hovers just over my shoulder, guiding me along my path, and if I am quiet and still enough to listen, she reminds me of the Divine that lights my path to understanding and trust."

She starts cutting and laying shapes down together, "waiting and listening for them to show me something."

Susan Sorrell

*G*rowing up, Susan has always had a wild imagination. Traveling around the world because of her father's job, she had to entertain herself with all kinds of arts and crafts. She didn't become serious about art until she made it her major and earned a bachelor's degree in visual design. She worked for a short time as a graphic artist, then went back to school and received her masters degree in education and began to teach art. Being around children was a great way to get her creative juices flowing. After 12 years of teaching, she decided to quit and become a full time artist.

"I love the way fiber art pushes the boundaries of traditional quilting and sewing," she states. With a love of adding color and texture to the fabrics, Sue is always on the lookout for anything she can find such as buttons, trim, unusual beads, old jewelry, rubber stamps, paint, and any other items to make her pieces unique.

Susan calls herself a mixed-media artist because she likes to dabble in a lot of different media. She combines painting, sewing, beading and embellishing on fabric and has opened up many new avenues to express herself. Her pieces are whimsical, colorful and have a personal theme. Her inspirations are drawn from her life and what is happening in the world. Susan currently lives in Greenville, South Carolina.

Happy Dog

"Happy Dog" is a 7½" x 11" piece painted on 100% cotton with textile and glow-in-the-dark paints. It is hand and machine sewn, beaded and embellished. The edges are beaded with a peyote stitch. The embellishments consist of buttons, old jewelry, and a variety of glass beads. The thread is embroidery floss.

"I love the way fiber art pushes the boundaries of traditional quilting and sewing."

Happy Dog

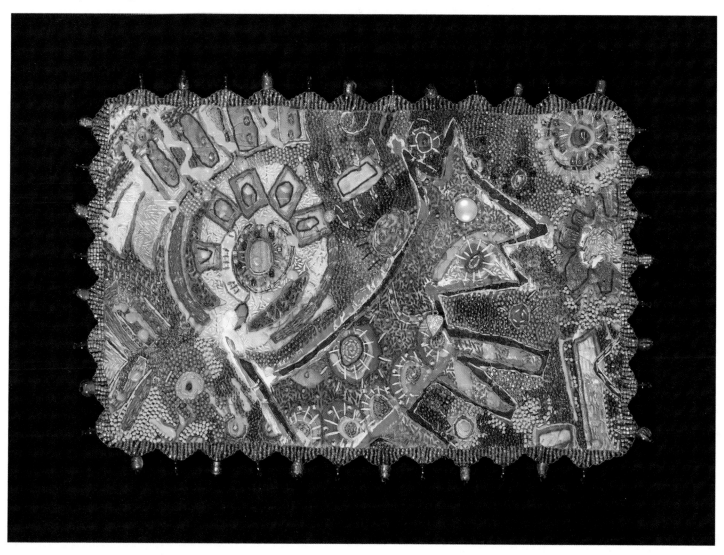

7½" x 11"

Saucered Coffee

This small 4" x 5" piece is packed with color, texture and design. It's part of a series that Susan calls "Southern Fried Fiber". It's painted on a piece of upholstery fabric, hand sewn with embroidery floss and beaded. The edge is a beaded peyote stitch. The saying around the edge of the piece is "SAUCERED AND BLOWED – COFFEE THAT'S BEEN COOLED DOWN."

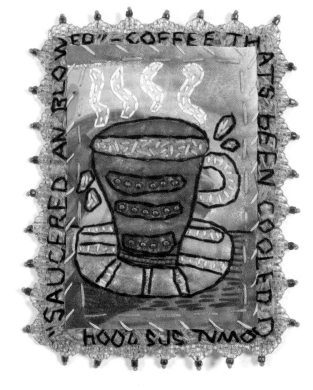

4" x 5"

Paint Box

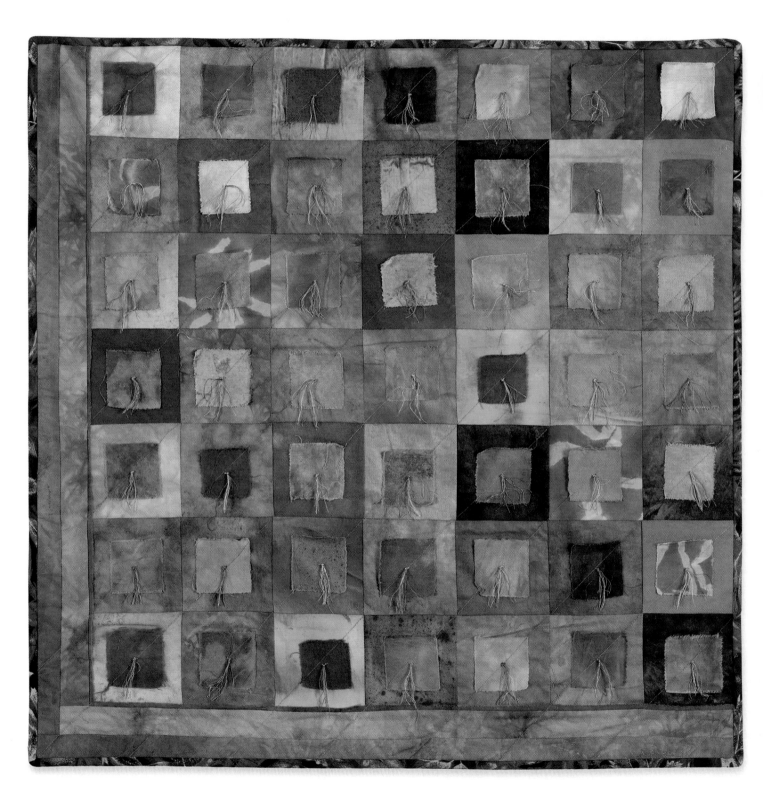

27" x 27"

Sharon Souva

This wall quilt was created using mostly hand-painted fabrics. Seta Color light sensitive water based paints were used. The construction of the piece was achieved by placing ripped squares of contrasting color fabrics on 4" squares with a small amount of fusible bond. These 4" squares were then pieced together and a border was added on two sides. The quilting is a very simple diagonal stitch done by machine using cotton quilting thread. The variegated cotton thread tassels were added as an embellishment.

Sewing is one of Sharon's greatest pleasures. She's been working with needles and fabric in one form or another since she was a child, starting with sewing her own, then her children's clothes.

She began making quilts in 1976, putting them on the walls instead of beds. As Sharon says, "this allows a greater freedom in exploring ways to manipulate fabric."

Several years ago, she discovered the joys of unfinished edges and loose threads. This has become an important part of her current work.

She finds herself looking at nature and man-made structures with the question: How could that be interpreted in fabric? How can these elements of texture and design be incorporated into these works?

This quilt artist comments, "The needle is an extension of my fingers, the threads and fabric, my palette. For me, color and pattern are equally important as my finished work. Fabric art is appealing to me, due to the fact that it's more than a visual art. It is very much linked with our sense of touch and with our memories."

Sharon's works have been shown in numerous museums and galleries in the Northeast. She currently makes her home in Syracuse, New York.

"The needle is an extension of my fingers, the threads and fabric, my palette."

Andrea Stern

Andrea Stern lives in scenic southeast Ohio, where she manages four kids, a dog, a turtle and a very supportive husband. She received her degrees in English and art history from Ohio University and actually uses both in her life as an artist. She is inspired by the color, texture and light of the rolling, hilly landscape that surrounds her rural home.

Andi comes from a long line of artists in all media, from the quilts made by her mother and grandmothers to the sculptures and furniture made by her grandfather and father. Growing up around all of that creativity was bound to rub off, and she finds that she keeps returning to the colors and textures of that happy childhood. Seeing the PBS show on Quilt National in the early 80s cemented that desire to make her work primarily in the fiber arts. That love of color, light and texture keeps returning in the form of the stitched textile, whether the stitching is with threads or beads. Andi has realized a 20 year dream —she has had a piece selected to be in Quilt National this year.

Cleaning the studio led Andi to the wonderful discovery of a black and yellow striped button which demanded to be put into a piece. She collects baby dresses and knew that one would be a perfect base to do a piece in the dirty yellows of #2 pencils, old measuring tapes and all those wonderful tools she remembers from her grandfather's garage. After removing the buttons on the dress, she sewed it to a piece of heavy-duty interfacing to give the piece body. She left the dress whole to give more weight to the finished piece, as beadwork gets very heavy. The beads were applied with a basic backstitch. She used a drill where necessary to attach the various found objects. She chose to leave the lace collar and arms unbeaded to give more depth to the piece. Once the embroidery was complete, the interfacing was carefully trimmed back and the finished dress was sewn to a piece of stretch canvas that she'd painted Blackboard Green.

She finds that she keeps returning to the colors and textures of her happy childhood.

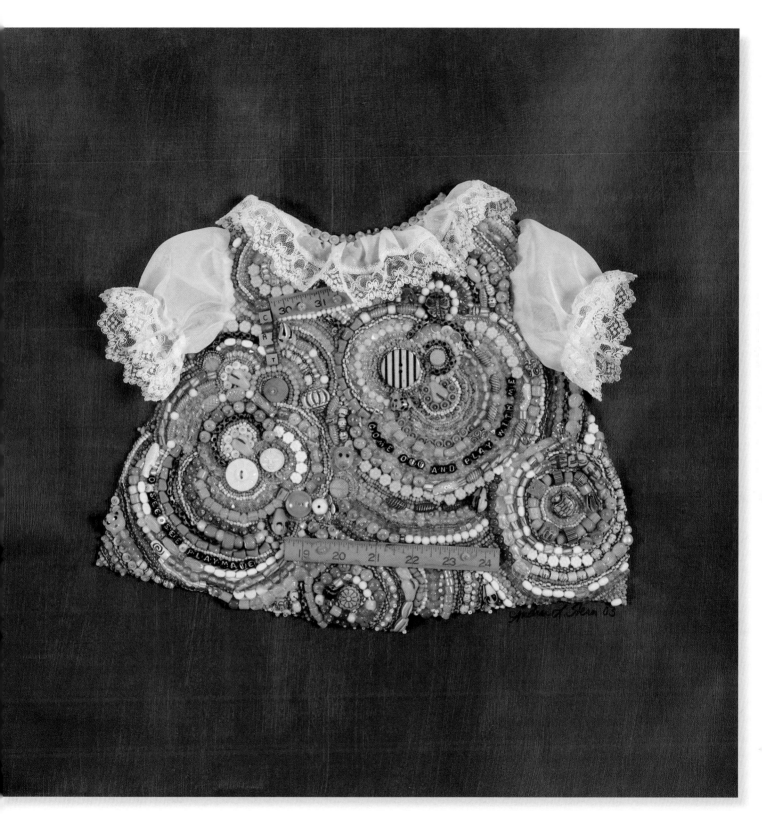

24" x 24"

Blue Weavings

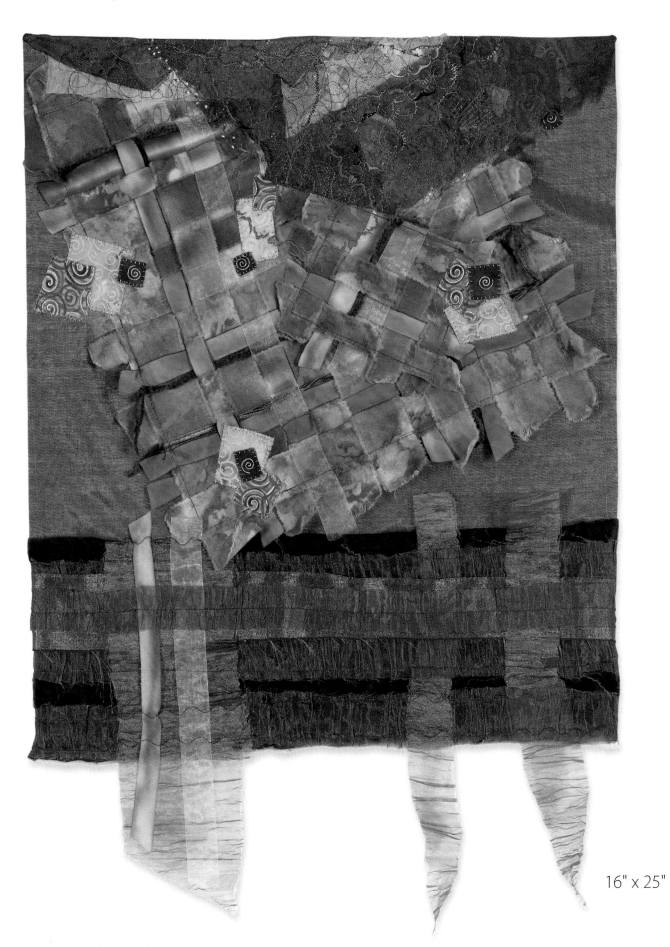

16" x 25"

Julia Vitero

This particular work was inspired by a frayed, woven rag rug. Julia used the blue batik-like fabric as a neutral color for a starting point. She started the piece by tearing fabric in different widths and fraying all the edges. She then pinned each horizontal row to a mat board before weaving the vertical rows, alternating with ribbons, yarns and fabric. A smaller similar square was stitched at an angle on the original piece. She stitched around the outside of the woven piece before it was given to other members of her quilt group for further enhancement. It was then that it became a truly collaborative effort. The original design was sewn on a shiny fabric; embellished with small squares outlined in gold threads. Velvet, and sheer materials and the shiny fabric were added to two sides to mimic the weaving. An abundance of decorative stitching was added over sheer fabrics.

The piece was then given back to Julia to finish. It was much larger than she envisioned and had a definite top and bottom. So she cut it to a smaller size, turned it upside down, and added more streamers to the border, incorporating some of the ribbons in the original piece.

Julia would like to thank Marilyn Handis-Tate, Karla Robinson, Marion Coleman and Patricia Montgomery for their enhancements of this piece.

Julia received her degree in business administration from San Francisco State College in 1959. Her first quilting experience was in Washington, D.C. in the late 1960s where she learned traditional quilting at the YWCA. In the class, they cut templates out of cardboard, traced patterns on fabric, cut with scissors and hand-pieced. She made two or three small hand-quilted pillows as gifts and then returned to her regular sewing. She didn't quilt again until about 10 years ago when a group at her office made a retirement quilt for one of their executives. Upon her own retirement, Julia started quilting again. Starting as a traditional block quilter, she is now experimenting with new and different techniques, colors and materials. Her work is influenced and inspired by everyday surroundings.

Julia currently lives in Oakland, California. Her works have been in several shows and her pieces are in many private collections. She has had two articles about her works in the San Francisco Chronicle.

The piece was given to other members of her quilt group for further enhancement. It was then that it became a truly collaborative effort.

Elin Waterston

After receiving her MFA in costume design, Elin Waterston worked as a wardrobe stylist in film and television. She also worked in costume shops building costumes and masks, painting, dyeing and manipulating fabrics. Eventually, that evolved into quilt making, which in turn evolved into art quilting. Her award-winning art quilts are in many public and private collections and have been exhibited in numerous art galleries. Elin is a member of the Studio Art Quilt Association and Fiber Revolution. She teaches at the Country Quilter in Somers, New York and Katonah Art Center in Katonah, New York. She lives with her husband and son in South Salem, New York.

Millie

A photo of Elin's grandmother as a child is the focus of this piece. Her grandmother explained to her that she wasn't smiling because she was unhappy that she was wearing her sister's shoes which were too big. The photo was printed on fabric and machine-appliquéd to a background fabric. Other fabric elements were added along with buttons to enhance the composition.

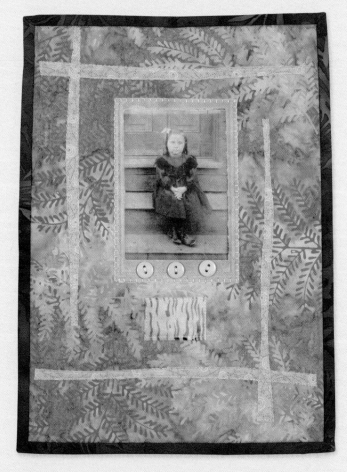

7½" x 10½"

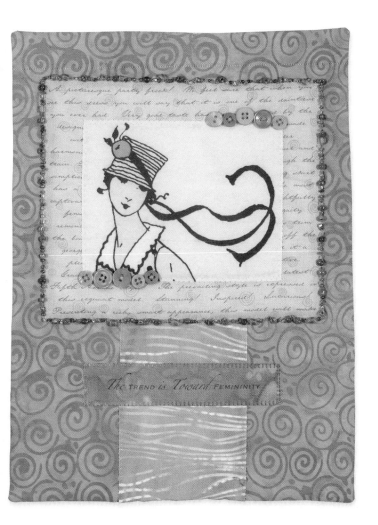

Toward Femininity

The central image in this piece is a fashion illustration from the French periodical *La Vie Parisienne*, which Elin colored in Adobe Photoshop© and printed onto fabric. The image was framed with fabric printed with words from old catalogs and appliquéd onto a collage of commercial fabric. After the piece was machine-quilted, beads and buttons were added as embellishments.

9" x 12"

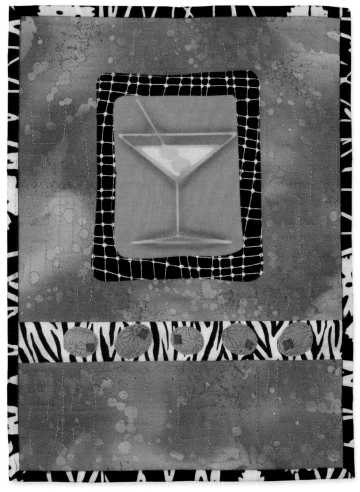

Perfect Martini #5

This piece started with a line drawing of a martini that Elin drew and colored in Adobe Photoshop©. After printing the illustration on fabric, she framed it, placed it on a background and added a row of fabric olives. It was then machined-quilted.

9" x 12"

Janet Wildman

Janet makes her home in Rockville, Maryland. She's studied fiber arts with several top teachers including Ruth McDowell and Susan Shie and traveled all the way to Sedona, Arizona and Monterey, California to further her painting and drawing techniques.

Her quilts have been exhibited in many juried, invitational and solo shows. She's received such awards as the 2004 Best of Show, Quilt Guild Challenge and Viewer's Choice from the 2001 Nimble Fingers Show.

Janet has been included in several publications including Fiber Arts Magazine, The Washington Post and The Rockville Gazette. She's affiliated with The Yellow Barn Studio at Glen Echo, Tuesday Quilters, American Quilter's Society, Rockville Arts Place, and Fiber Arts Study Group.

Janet dyed the background fabric for this piece using the low-water immersion dying technique. She doesn't follow a specific formula to create the combination of colors, so each piece is a wonderful surprise. This particular piece was inspired by the surprise color of the background fabric. She had begun doing some oil painting about a year ago and wanted to incorporate her painting with her quilting, so she purchased a faux painting tool at her local hardware store. It looked like something that might be useful and bingo!—she had an idea for this small quilt.

She applied bronze fabric paint using the small rolling tool that she had purchased and applied the paint in columns and rows using only her eye to keep it symmetrical. Once the painted piece of fabric was complete, she then placed the painted quilt top on top of a layer of lightweight cotton batting and a background fabric that complemented the design.

Once she completed the quilt "sandwich", she hand-stitched the quilting lines using a sashiko design (longer stitches which are more visible than the traditional quilting stitch) and three strands of bronze embroidery floss. For a final touch, she added French knots and beading to each square and applied string beading at the bottom of the piece.

…she purchased a faux painting tool at her local hardware store. It looked like something that might be useful and bingo!—she had an idea for this small quilt.

Repetitions in Bronze

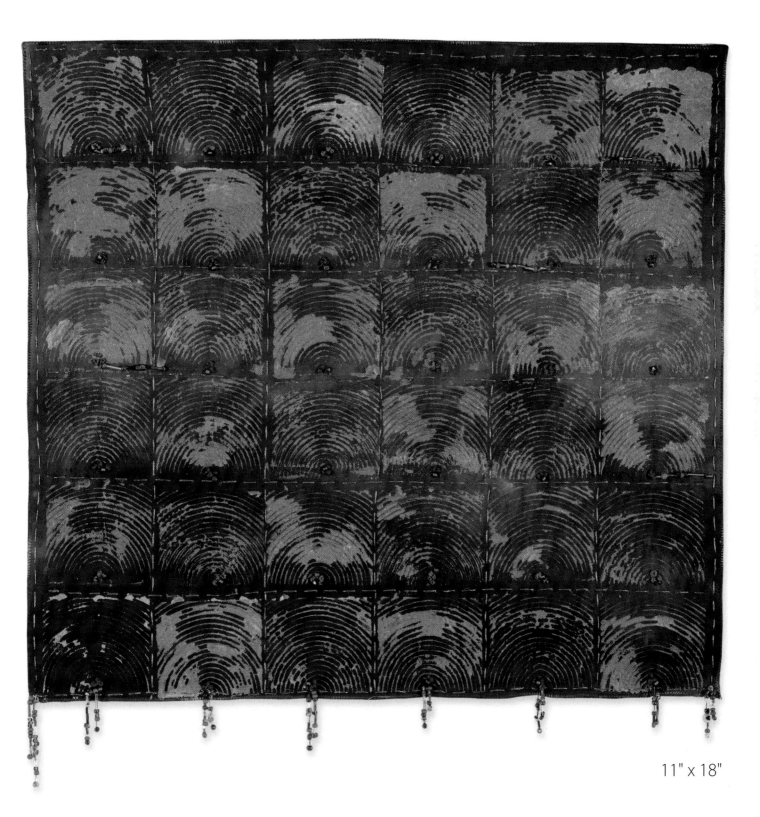

11" x 18"

Remember When

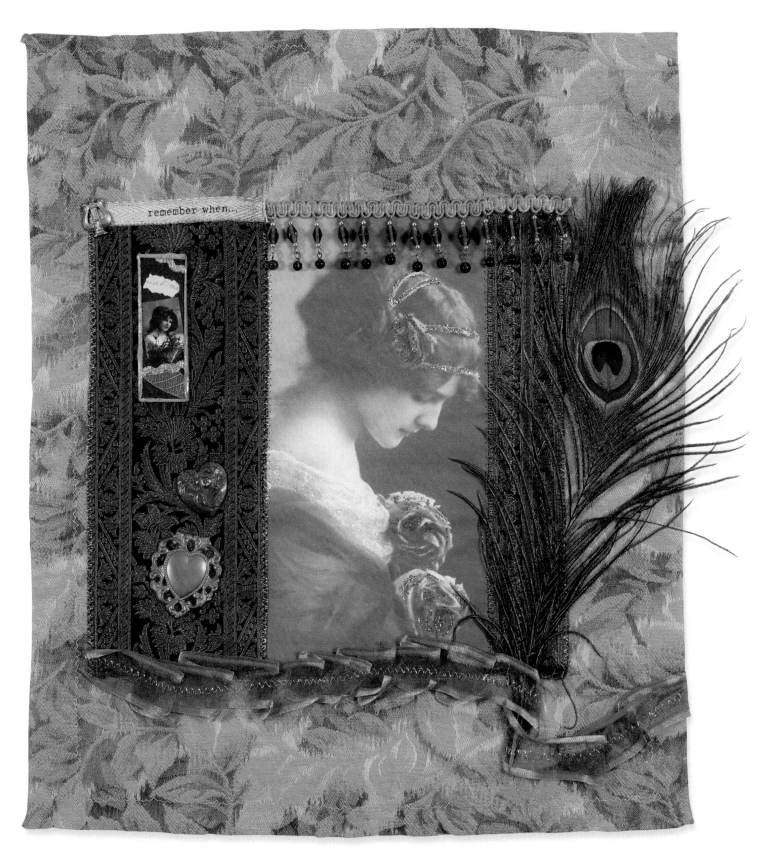

remember when...

13¾" x 16"

A Novice Creates Fabric Art

Of course, I knew I could never make something like the artists featured in this book. They're the real experts and most of them have had years to learn their craft.

But I was given the assignment to study the pieces—to look at the photos, read the descriptions and then create my own version of a fabric art piece . I was given this assignment because I'm the one at Banar Designs with the least sewing experience. The logic was, if I could do it, anyone could. I took a sewing class in junior high school in which I learned to make a gathered skirt (which I never wore!). I took another class later when I purchased a Singer sewing machine for $50.00 (the class came with the purchase of the machine). After that, the only sewing I did was to make Halloween costumes for my daughter. Since these were only worn once, they didn't have to be constructed very well.

I've wanted to learn to make quilts for years because I love fabrics. But the idea of measuring and making all those squares and strips match up really threw me. Art quilts appealed to me because of the creativity and the freedom from strict sewing rules. I was so inspired by the freedom and creativity of the fabric artists in this book that I decided to try my luck.

Nancy Javier

Here's how I went about creating "Remember When".

1. I chose the photograph for the focal point of the piece. I just loved this gorgeous photo of a silent screen star.

2. I printed the photograph on paper in a copy machine, then I chose the fabric that I thought coordinated nicely with the photo.

3. The next step was to select the embellishments—the ribbons, charms, peacock feather and the microscope slide (this was made earlier as an experiment in soldering).

4. I laid all these things together until everything looked just right.

5. I scanned the photograph in the computer and then printed it on a computer fabric sheet from Printed Treasures by Milliken on an Epson C80 inkjet printer. The backing paper was removed and the fabric was trimmed to size.

6. I cut the backing fabric to the desired size, then sewed the photo onto the backing using gold metallic thread and a zigzag stitch. I bordered the photo with wide tapestry ribbon on each side also using the zigzag stitch.

7. The twill "remember when" ribbon by 7 Gypsies was sewn to the top part of the tapestry ribbon and the beaded trim was glued to the top of the photo.

8. The gold-edged ribbon was gathered and pinned to the bottom part of the photo and then sewn on using a zigzag stitch and gold metallic thread. I created a pocket in the ribbon for the feather to fit in. It was inserted, then tacked down in a few places to secure it.

9. Thin batting and a backing fabric were added to the piece.

10. The charms were glued on in various places as well as the microscope slide.

11. To finish, I used different colors of Sparkles glitter glue by PSX to highlight areas of the photograph.

(See the following technique pages to help you create your own fabric art.)

Techniques

DYEING FABRIC

Several of the artists in this book have dyed their own fabrics using different techniques and different types of dye. See Deb Lacativa's piece on page 30 for an example of her dyed fabrics. Sharon Souva's quilt on page 62 also exhibits some spectacular dyeing techniques. There are a multitude of dyes and techniques that can be used to create some very interesting results. The following are just a few to get you started.

Immersion (Vat) Dyeing

Immersion dyeing is used when you want to dye large pieces of fabric (3-6 yards) and want an even color. To dye fabric you'll need:

 Fabric dye of your choice
 1 gallon container
 Measuring cups and spoons
 Containers for dye, either glass
 jars or clear plastic cups
 Mixing sticks
 Paper towels
 Gallon heavy plastic freezer bags
 Plastic dishpans
 Drop cloth or newspapers to
 cover work surface
 Rubber gloves
 Dust mask
 Non-iodized salt
 Soda ash (washing soda)
 Water softener (optional-this
 creates a more even color)
 Mild detergent
 Large tub

1. Prewash fabric with the mild detergent.

2. Dissolve:
 3 cups of plain salt in
 3 gallons of lukewarm water
 2 teaspoons water softener
 (optional)

3. Dissolve 1 teaspoon of dye (per lb. of fabric) in 1 cup of warm water.

4. Add the fabric to the dissolved mixture and stir every 3 minutes for 20 minutes.

5. Dissolve 1/3 cup soda ash in hot water and slowly add it to the dye mixture (over about 15 minutes). Soak the fabric in the dye. Don't pour the dye directly on the fabric. Let this sit for 30 minutes to an hour depending on how intense you want your color. Stir frequently.

6. Remove the fabric from the tub and rinse to remove excess dye.

7. Wash the fabric in hot water with the mild detergent to remove any remaining dye.

Soda Ash Soak Dyeing

This type of dyeing creates uneven patterns and textures on your fabric with color gradations and textures by folding, scrunching, twisting, and tying. You'll need the same equipment that you use for immersion dyeing (see above).

1. Pre-wash your fabric using a mild detergent.

2. Soak the fabric in:
 1 cup soda ash
 1 gallon water

3. While the fabric is soaking, mix up chemical water:
 1 teaspoon water softener
 or soda ash
 1 quart water
 (for larger quantities, use the same ratios and increase the amounts accordingly.)

4. Mix 1 teaspoon dye powder to the chemical water you just mixed.

5. Optional: add 3 cups of salt.

6. Sponge the solution onto the wet fabric and let it flow and blend. Roll it in plastic wrap and place in a plastic bag to cure for 24 to 48 hours. If you want to add texture to the fabric, try scrunching, folding or twisting the fabric after you roll it in the plastic wrap.

You can decrease or increase the amount of dye powder that you use depending on the intensity of color desired. It might be helpful to keep a chart with amounts of dye used and the texturizing method you used. Staple a small sample of the finished piece to your chart. Then in the future you can recreate the same or similar fabric.

Discharge Dyeing Technique

Discharging refers to the removal of color from fabric by using bleach. Quilters like this technique for creating some unique looks to their pieces.

Darker fabrics (100% cotton) work best for this technique. Many interesting effects can be achieved as colors are exposed in this process.

What you'll need:

 Chlorite bleach
 2 – 3 large containers
 Rubber gloves
 Fabric to be dyed
 Optional: spray bottle and masking
 objects such as leaves, dye cut
 shapes, etc.

Discharge Dyeing Technique
Method #1 – Vat dyeing

1. Fold or scrunch the fabric (similar to tie dyeing). Use rubber bands to keep folds in place.

2. Then dip the fabric in 1 part bleach to 2 parts water.

3. Remove the fabric from the bleach mixture.

4. Soak it in a container of clear water for about 3 minutes.

5. Then soak it in a container of 3 parts water to 1 part vinegar (or Antichlor – available in the fish department of pet stores) for 3 minutes.

6. Soak again in clear water.

7. Launder with detergent

Discharge Dyeing Technique
Method #2 – Spray dyeing

1. Instead of dipping the fabric, it will be sprayed with bleach. It's interesting to use a mask (such as leaves, flower petals, die cut shapes, etc.) on the fabric and then spray over the top of the mask leaving a lighter impression.

2. Continue with steps 4 – 7 above.

Techniques

FREE MOTION STITCHING

Free motion stitching is a method of quilting where the feed dogs of the sewing machine are lowered or covered. The quilter controls the movement of the fabric under the needle. Quilt artists use this technique as a way to create detail, add texture and color and to breathe life into their works.

Several of the quilt artists represented in this book have used free motion stitching in their work. Good examples can be seen on the works of Phil Jones (page 22) and Grace Errea (page 78).

If you decide you want to try free motion stitching—here's what you'll need:

- Your regular lock stitch sewing machine (one with a top and bottom thread)
- A hoop or darning foot (check your manual for instructions)
- A built-in zigzag stitch is helpful
- Stabilizers or interfacing, especially for wallhangings
- a wooden hoop (for machine embroidery) if you need more stabilizing (optional)

All free motion work is straight stitching. There are three basic skills:

1. Drawing – moving in any direction, back and forth in patterns to add texture.

2. Stippling – fill-in stitches, such as swirls, sweeps, and curves.

3. Signatures – this is for signing your name in your work.

All of these skills take practice. It's a good idea to take a scrap of fabric with batting and backing fabric and start stitching. If you have some print fabric lying around, use it to practice. Follow the design of the fabric practicing straight up and down stitches, then try some swirls and curves. The more you practice, the better you'll become.

Free Motion Stitching Tips

1. Stitch at a medium pace. If you go too slow, the stitches will be jerky and uneven. If too fast, your fabric movement can't keep up with the machine.

2. If the thread tends to break, loosen the needle tension slightly and slow down.

3. If you have skipped stitches, hold the fabric flat against the machine bed. If skipping continues, move your fingers closer or use a darning spring needle.

4. If you're not confident with your skills, trace the desired design onto the fabric with a water soluble marker and follow the design.

ADDING EMBELLISHMENTS

Since art quilts are not meant to be slept under like traditional quilts, they can be embellished with as many types of things as your imagination can conjure up. You can sew on beads, buttons and charms. You can glue on polymer clay images, sew on any kind of found object you can think of, even paper.

Flip through these pages and you'll see lots of other embellishing ideas:

Beads – Sue Sorrell, Therese May, Andi Stern
Buttons – Rose Rushbrooke
Charms –Jane LaFazio
Found objects – Lynn Krawczyk
Paper – Louise Thompson Schiele
Polymer clay – Lynn Krawczyk

Some of these embellishments can be sewn on such as beads, buttons and sequins. Others may need to have small holes drilled before they can be sewn on. If this is not possible, then gluing is the next best choice. E6000 is a good adhesive for adding embellishments to art quilts.

Couching

If you're going to be adding various embellishments to your art quilt such as fancy fibers, lace or other trims, you might want to attach them using a couching stitch. Couching is usually done by hand with a needle and either embroidery floss, thread, metallic or decorative threads. Some embellishments can also be added using your machine and a zigzag stitch.

The ends of the embellishment can either be sewn into the seam allowance or ended with two or three small tight stitches. Or cover the ends with beads, buttons, charms or sequins.

Adding Beads

Beads add luster, texture and sparkle to an art quilt. To begin, study your fabric selection and match the beads to your fabric. Decide whether to use a mix of bead sizes and types or just a touch of similar beads to fill in an area.

1. Using about 24" of Silamide beading thread and a size 10 milliner's or straw needle, double the length, then knot the end.

2. Bring your needle from the back of your piece to the front (through all layers of your piece).

3. Load a bead onto the needle and take a stitch down through the layers.

4. Bring the needle back up in the next area and add another bead.

5. Continue until the thread gets too short. Then bring the needle back through the piece to the back and knot close to the fabric and take a stitch to secure the thread.

6. Continue with a new length of thread.

Adding Sequins

1. Follow steps 1 and 2 above.

2. Add a sequin to the needle along with a seed bead on top.

3. Stitch back through the sequin but not the bead. This locks the sequin and bead onto the fabric.

Note: Use this same technique for applying buttons and charms.

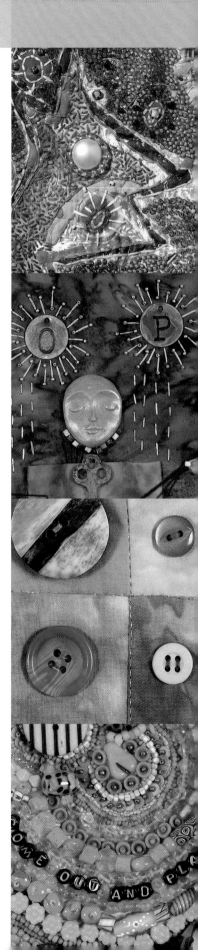

Techniques

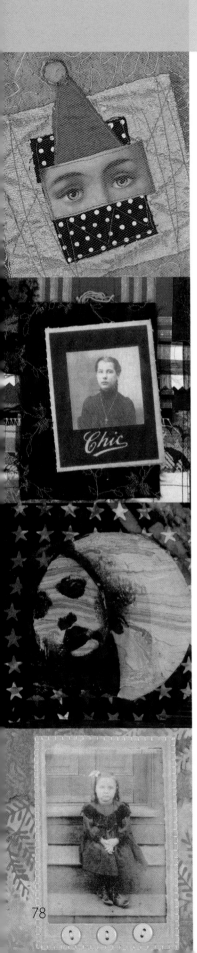

MAKING FABRIC COPIES FROM YOUR COMPUTER OR PRINTER

If you own a home computer, try using it to print photographs on fabric that can be used as embellishments on your projects. See examples on works of Eliza Brewster (page 4) and Lesley Riley (page 48). Elin Waterston has also done some interesting transfer work on her pieces on pages 68 and 69.

There are several products on the market that include fabric with a paper backing that can go through your computer printer or a copy machine. After printing the image, you remove the backing paper and the fabric piece is ready to use.

If you're using your computer, you can either scan in clip art, photos, or illustrations. Also, use your computer to create type. You can print out these items on the computer printer fabric. Just put it through your inkjet printer as if it's a piece of paper.

If you don't have a computer, you can put this printer fabric through an inkjet copy machine. If you don't have a copier, your local print shop will make copies for you.

There are fabrics available printed with vintage photos from a company called Artchix (artchixstudio.com). There are also fabrics with illustrations or paintings printed on them from Daydreams Art Fabric (www.colfaxcloth.com). These would make beautiful additions to art quilts.

All of these images can either be fused or sewn to your projects to create some very interesting fabric art designs.

MAKING YOUR OWN COMPUTER FABRIC SHEETS

You can save money by creating your own computer fabric sheets. After you've made the sheets, you can print on them using your computer printer. Here's how you do it:

You'll need:

- The fabric you want to print on (cut slightly larger than the size you will be printing) – 100% cotton or 100% silk
- Bubble Jet Set 2000 (or other ink fixative)
- Freezer paper or adhesive label sheets
- Rotary cutter, ruler and cutting mat
- Iron
- Flat pan
- Rubber gloves

1. Shake the ink fixative well and then pour into a flat pan. Wearing the rubber gloves, saturate the fabric in the solution for five minutes. Allow fabric to dry.

2. Iron fabric to the smooth side of freezer paper (don't use steam in your iron). Make sure the fabric is thoroughly bonded to the paper so that you don't have any air bubbles.

3. Cut the fabric/freezer paper the size to fit your printer.

4. Print the image using your printer (following your manual). Let sit for 30 minutes.

5. Remove the fabric from the freezer paper.

6. Machine wash the printed piece on delicate in cold water and a mild detergent.

According to the manufacturer of Bubble Jet Set, the printed fabric should not be heat set. But, it must be washed with a mild detergent in order for the product to work correctly. If you don't wash in the detergent, the fabric will bleed.

Hint: Print your copy on paper first before you print on the fabric. Then, if you need to make adjustments, do so before printing on the fabric. All printers and computer programs work differently, so consult your manuals for how to do the print settings.

INKJET PRINTERS

If you're going to print on fabric, you'll need an ink jet printer. There are lots of them on the market. But the most versatile is the all-in-one printer that prints, faxes, scans and copies. This type of printer doesn't require a computer for simple printing. They're easy to use and the print quality is excellent.

RUBBER STAMPING

Another excellent way to add images to fabric is to use rubber stamps. There are a million stamps on the market from simple designs on foam stamps to elaborate art collage stamps. Check your local craft store or stamp store to see the infinite variety of stamps available. Betty Hirsh used rubber stamps to add the fish images to her "Fish Bowl" design (page 16). Pat Kumicich used rubber stamps for her quilt (page 28).

To use rubber stamps on fabric:

It's best to stamp on solid fabric or one with a subtle print so that your design will show up. You may want to paint your fabric first (using your choice of fabric paint) and then stamp your image over the top.

Or stamp the image on solid fabric and then use paints or fabric markers to color in the design. Betty used metallic paints for her "Fish Bowl" design. You could also use colored stamp pads to achieve different results. There are now stamp pads just for fabrics.

How to stamp:

Apply the stamp on the pad.

Stamp it on a test piece of paper first to make sure that it stamps completely.

Re-ink your stamp again and stamp it on the fabric.

Other ideas for stamping:

- You can also ink your stamp with a colored marker. Color the complete image area or only part of the image. Or use different color markers on the stamp for a multi-colored effect.

- Spray your stamp with bleach and stamp on dark fabric.

- Or use a cosmetic sponge to apply acrylic or fabric paint to the stamp, then stamp on your fabric.

Experiment with different types of paint or stamp pads to get the effect you want. There are so many different types. Try metallic paints for some unique effects.

Check the labels on paint or inks to see if your fabric needs to be heat set after stamping.

The Artists

Eliza Brewster
1991 Great Bend Turnpike
Honesdale, PA 18431
Website: www.fineartquilts.com

Robin Cowley
2451 Potomac Street
Oakland, CA 94602
Email: art@robincowley.com
Website: www.robincowley.com

Chiaki Dosho
4-1-1-221 Hakusan,
Asao-ku, Kawasaki-shi
Kanagawa-ken, Japan 215-0014
Email: chiakid@col.hi-ho.ne.jp

Grace Errea
Email: errea@us.ibm.com

Elizabeth W. Fram
Washington Crossing, PA
Email: ehwfram@comcast.net

Janet Ghio
Email: jaghio11@ktc.com
Website: www.quiltcollage.com
Betty Hirsh
Email: bahirsh@comcast.net

Betty Hirsh
Email: bahirsh@comcast.net

Laura Jennings
2170 Ironwood St.
Eugene, OR 97401
(541) 687-1190
Email: laurajenn@aol.com

Marjorie Johnson
Modesto, CA
(209) 548-9484
Email: fabricart@bigvalley.net

Phil D. Jones
Denver, CO
Email: phil@phildjones.com
Website: www.phildjones.com

Peg Keeney
Email: keeney10@charter.net
Website: www.pegkeeney.homestead.com

Lynn Krawczyk
580 Forest Avenue, Unit #1
Plymouth, MI 48170
(734) 453-1340
Email: FibraArtysta@earthlink.net
Website: www.fibraartysta.com

Pat Kumicich
Email: grannyknot@yahoo.com
Website: www.pkartquiltstudio.com

Deborah Lacativa
Lawrenceville, GA
Email: deborah@lacativa.com
Website: www.lacativa.com

Jane LaFazio
(858) 451-6429
Email: Jane@PlainJaneStudio.com
Website: www.PlainJaneStudio.com

Kathleen Loomis
Louisville, KY
Email: kloomis@aye.net

Therese May
651 N. 4th St.
San Jose, CA 95112
408 292-3247
Email: therese@theresemay.com
Website: www.theresemay.com or
www.quiltpower.com

Margit Moraweitz
Phoenix, AZ
Email: picklegreen@cox.net

Edna J. Patterson-Petty
East St. Louis, IL
Email: ebonygirlp@aol.com
Website: www.fabricswork.com

Judith Plotner
Email: justa@klink.net

Wen Redmond
First Star Farm
441 First Crown Point Road
Strafford, NH 03884
Email: wenreddy@yahoo.com
Website: www.WenRedmond.com

Lesley Riley
Email: LrileyART@aol.com
Website: www.lalasland.com

Connie Rohman
1031 Avenue 37
Los Angeles, CA 90065
Email: crohman1@yahoo.com

Rose Rushbrooke
Email: rose@roserushbrooke.com
Website: www.roserushbrooke.com

Louise Schiele
Fiber Collage Artist
2845 Rascommon Way
Sacramento, CA 95827
(916) 361-8958
Website: www.weezeewear.com

Karen Smith
BlissArt & Blue Wolf Studios
170 Cedar Crest Road
Nogal, NM 88341
(505) 354-0602
Email: blissart@zianet.com

Susan R. Sorrell
601 Cleveland St. 12F
Greenville, SC 29601
(864) 233-8934
Email: sorrell@creativechick.com
Website: www.creativechick.com

Sharon Souva
Email: smsouva@five95.net

Andrea L. Stern
PO Box 559
Chauncey, OH 45719
Website: www.embellishmentcafe.com

Julia Vitero
Email: viteroquilts@yahoo.com

Elin Waterston
South Salem, NY
Email: info@elinwaterston.com
Website: www.elinwaterston.com

Janet Wildman
Rockville, MD
voice mail: (301) 948-5079
Email: janetwild@comcast.net